DISCOVERING ART

The Life, Times and Work of the World's Greatest Artists

IMPRESSIONISTS

K. E. SULLIVAN

BROCKHAMPTON PRESS

For Cole

The author would like to acknowledge the following valuable sources:
John House's *Monet, Nature into Art*, Steven Adams' *The World of the Impressionists*
and Phoebe Pool's *Impressionism*.
Thanks also to Anne Newman for inspired editing.

First published in Great Britain by Brockhampton Press,
a member of the Hodder Headline Group,
20 Bloomsbury Street, London WC1B 3QA

ISBN 1 86019 125 8

Produced by Flame Tree Publishing,
The Long House, Antrobus Road, Chiswick, London W4 5HY
for Brockhampton Press
A Wells/McCreeth/Sullivan Production

Printed and bound by Oriental Press, Dubai

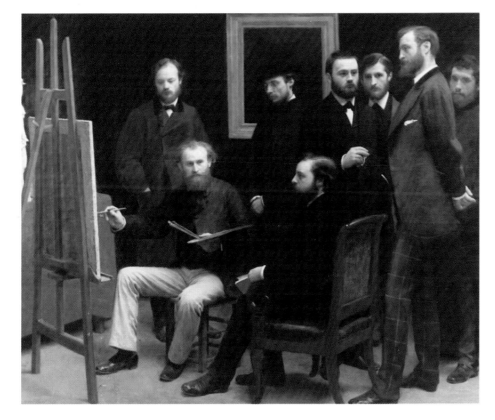

CONTENTS

Studio at the Batignolles, Fantin-Latour, 1870 (Musée d'Orsay, Paris). Manet is shown here, in a group of admirers. He is painting the critic Astruc (seated next to him), and from left to right are: Ottoscholderer (a painter), Renoir, Zola, Maitre, Bazille and Monet.

INTRODUCTION

The term Impressionism refers mainly to a popular movement, engaging the talents of a band of gifted artists who took the unorthodox step of organizing an independent exhibition of their works. Their similarity lay mainly in their shared vision and their communal outlook, while their principles and styles were markedly different.

In general, the Impressionists were against the academic training of contemporary schools, rebelling against Romanticism and embracing some of the components of Realism. Their themes, however, were as diverse as their natures; Degas painted dancers, horse races and laundresses; Renoir painted all that was beautiful to him – women, children, charming landscapes and social events; Monet, Sisley and Pissarro painted mostly landscapes.

Within this broad spectrum of themes lay a common exploration of the truth of colour and the effect of light on that perception. The Impressionists sought spontaneity – to capture the visual impact of a subject, to record its impression rather than its permanent aspect. Great emphasis was placed on painting out of doors, *en plein air*, and on finishing the picture where they began it, before the conditions of light and atmosphere changed.

Shadows were never painted in black or grey, but in a colour complementary or in contrast to the colour of the object. Colour defined and outlined instead of filling space. Renoir's introduction of the rainbow palette (the divisionist technique) and the elimination of black outlines and shadows gave Impressionist paintings an immediacy; their works became identifiable as paintings of light and atmosphere where light and colour became inextricably intertwined. Renoir's innovations resulted in a major change in direction for the Impressionist painters, and they were undertaken first by Pissarro and then by Monet, Sisley, and even the *enfant terrible*, Manet.

These theories were not entirely new. In many ways the art of the Impressionists was heralded by the out-of-doors painting of the Barbizon school, the studies of the Dutch painter Johan Barthold Jongkind, the work of Rousseau and Corot. The English landscapist, Constable, was an important influence, and the colour skills of Delacroix were adopted. Courbet and Boudin were also recognized as important initiators of the movement. This scandalous new school of art had not come unannounced – it had been knocking at the door of the art establishment for quite some time.

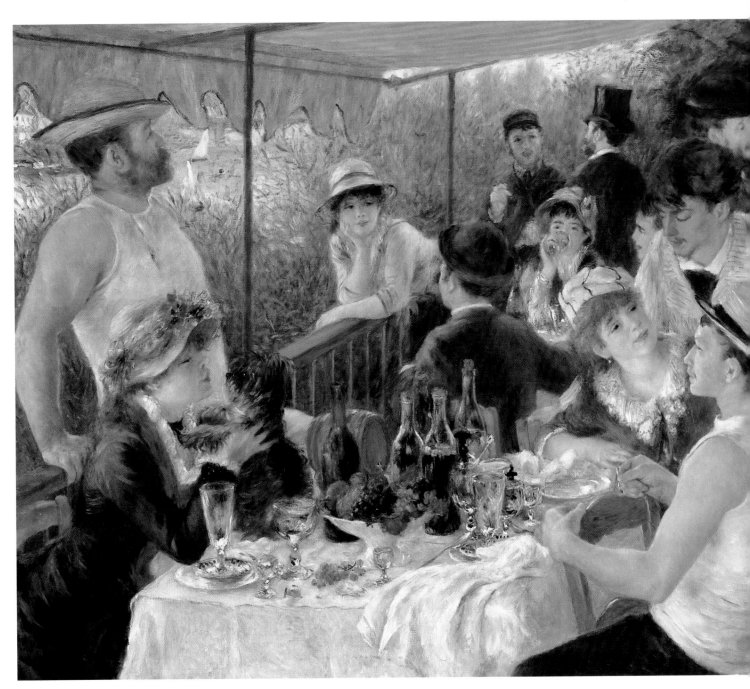

Detail from **Luncheon of the Boating Party, Renoir, 1880-1** (Phillips Collection, Washington). Renoir had an extraordinary ability to capture the babble of café society. The atmosphere of this painting is gay and relaxed, and the composition elegant. Renoir's lover Aline Charigot is seated at the front left.

CHAPTER 1

Beginnings

One morning one of us had run out of black, and that was the birth of Impressionism.

Pierre-Auguste Renoir

Overleaf:
La Grenouillère, Monet, 1869
(Metropolitan Museum of Art, New York). Monet and Renoir sat side by side at this popular bathing site, painting the same scene over and over again. These paintings would become some of the most representative works of the Impressionist school.

Beach at Trouville, Boudin, 1863
(Phillips Collection, Washington). Boudin was Monet's primary influence, encouraging the young painter to work out of doors. Boudin is accorded the honour of being the main precursor to the Impressionist movement.

Paris in the mid-nineteenth century was undergoing a dramatic transformation. The economic recession which had been a catalyst for the 1848 revolution was over by 1851, and Napoleon instigated a celebratory refurbishment of the city, which reflected the new prosperity and splendour of the times. Over the course of only a few years, a cosmopolitan urban centre evolved from what had almost become a medieval city. Wide, tree-lined boulevards, elegant restaurants and cars, theatres, music halls and luxurious apartments proliferated.

There was a surge in export, the resulting industrial revolution changing the nature of most French work and attitudes. The city became the hub of day-to-day life, leisure activities were undertaken on its streets, the suburbs boomed with new converts to city life. The countryside lost its appeal and holidays were now taken within commuting distance. There was a mood of euphoria pervading the streets of Paris. The heady days of the *belle époque* had begun.

Paris was a fascinating and vibrant place in the 1850s and 1860s; café society was at its height and the city had become a mecca for bright, impressive young men and women. Industrialization had freed society from drudgery and nowhere was it more obvious than in the bubbling, stimulating streets of Paris. Food, chatter, colour and light were plentiful; even those with little money could breathe in the atmosphere, experience the energy.

It was into this world that the school of art which would come to be known as Impressionism was born.

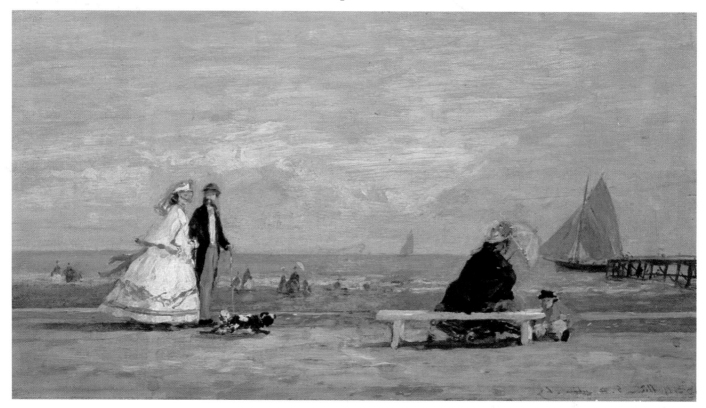

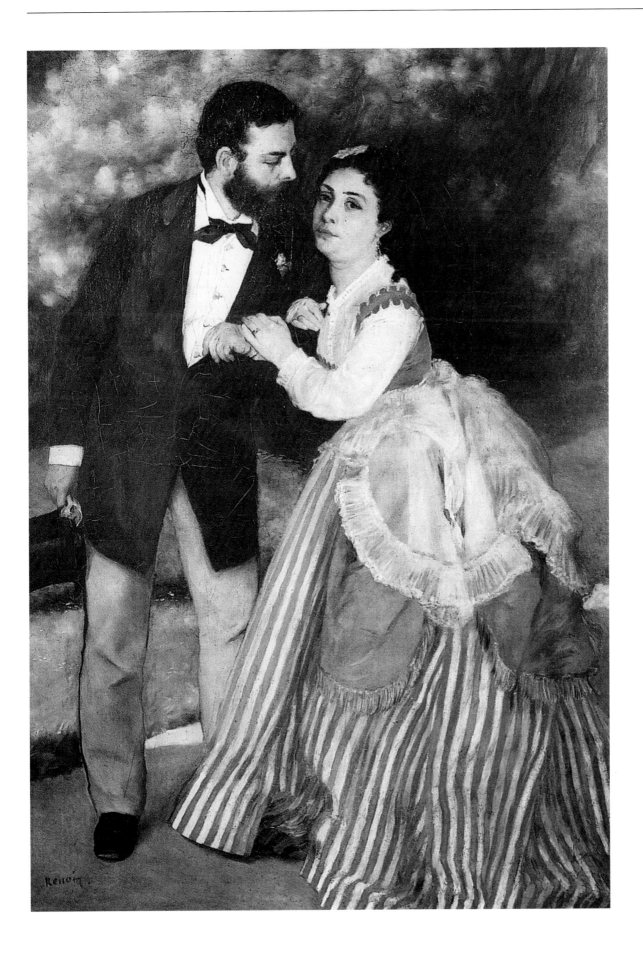

The art world had not been imbued with the reckless enthusiasm that characterized the spirit of new growth elsewhere. Paintings were expected to be serious, refined and conservative, calling upon classical traditions and being vested with moral rectitude. Art during this time was considered to be a reflection of the spiritual health of the nation. After years of war, which had begun at the turn of the century, French national pride was at a low and art was accorded the responsibility of lifting the spirits, of reviving confidence in the nation and her future. History, tradition, a celebration of the classical and what was generally accepted to be beautiful became the only approved subjects for paintings. Anything outside this definition was considered not only rebellious, but positively unpatriotic.

For an artist, the only path to financial success in the 1860s lay through the Salon, the prestigious annual exhibition held at the Louvre in Paris at which the very best painters, in the opinion of the rather staid and official jury, had their work represented. Critics and potential patrons frequented the Salon and a successful exhibition might guarantee a certain number of lucrative commissions for an artist. The selection of paintings at the Salon reflected very much the academic traditions and the artistic tastes of the establishment. There was very little scope for creative ventures and the same styles were represented over and over again. French academic art was completely reliant upon the state for funding, and was susceptible to changes in political power. Good art was that which was in fashion with whomever was in power.

In 1816 the French Académie had been reconstituted to become Académie des Beaux-Arts, with a school, Ecole des Beaux-Arts, forming part of it.

Aspiring artists were aware that the Académie alone would assure them a strong enough reputation to acquire the necessary prestige and fortune; they were required to study at the Ecole and under the tutelage of a suitable master, many of whom formed a part of the jury for the Salon. Success meant showing at the Salon, becoming a tutor oneself, and then guaranteeing in this manner that subsequent work would be well received within the sacred halls of the establishment.

The Romantics had been the first movement to challenge this ideology. Their articulate and resourceful leader, Eugene Delacroix, was extremely influential, using the strong, bright colours and brush-strokes which heralded those of the Impressionists – small, unjoined daubs, which suggested rather than described. But this work was not considered remotely saleable, and although it may have engendered secret admiration among various elements of the arts, most of the critics called it brutal.

Some other young artists shared a rebellious spirit, although they did not set out on a revolutionary path. Monet, Renoir, Pissarro,

The Little Gardener, Bazille, 1867
(Houston Museum of Fine Art).
The first stirrings of Impressionist
technique were making themselves felt
around this time; the foreground of
Bazille's superb landscape represents
touches of the developing style.

Bazille, Sisley and Morisot had begun their studies in order to realize their fledgling dream of showing at the Salon, but their course was to take them far from its doors.

The most powerful exponent of the French Impressionists, Claude Oscar Monet, was born in 1840, the son of an affluent Parisian grocer. He was born by the Seine, the river which flows through the heart of Paris, and into eastern France. For the rest of his life he would make his home on its shores. Water was an obsession for Monet; from his earliest days he would paint it, struggle to capture its light, reflections and colour.

Monet's family was not artistic, but Monet's skills were recognized, and to a certain extent encouraged. They had moved to Le Havre when Monet was a child and he became known there for his irreverent caricatures of schoolmates and locals.

When Monet was eighteen he met Eugène Boudin, and this was reputedly the determining factor in his decision to become a painter.

Boudin was a local landscape painter, but he had already achieved some recognition among his peers; in particular, Constant Troyon, Thomas Couture and Jean François Millet, each of whom painted in a different style but all of whom had achieved some critical success.

Boudin himself painted out of doors, documenting with splendid precision and originality the movement of water, air, clouds, trees; in fact, everything that a moment in nature presented. Boudin was extraordinarily influential in Monet's life, and he has been accorded the honour of being the Impressionists' first real inspiration. Boudin admired the work of Monet, and he recognized his gift for colour. Monet wrote later:

One day Boudin said to me, '... appreciate the sea, the light, the blue sky.' I took his advice and together we went on long outings during which I painted constantly from nature. This was how I came to understand nature and learned to love it passionately.

La Grenouillère, Renoir, 1869 (Stockholm National Museum). Renoir considered these early Impressionist paintings to be sketches from which he would later work. No one realized that these unfinished works would become some of the greatest paintings in art history.

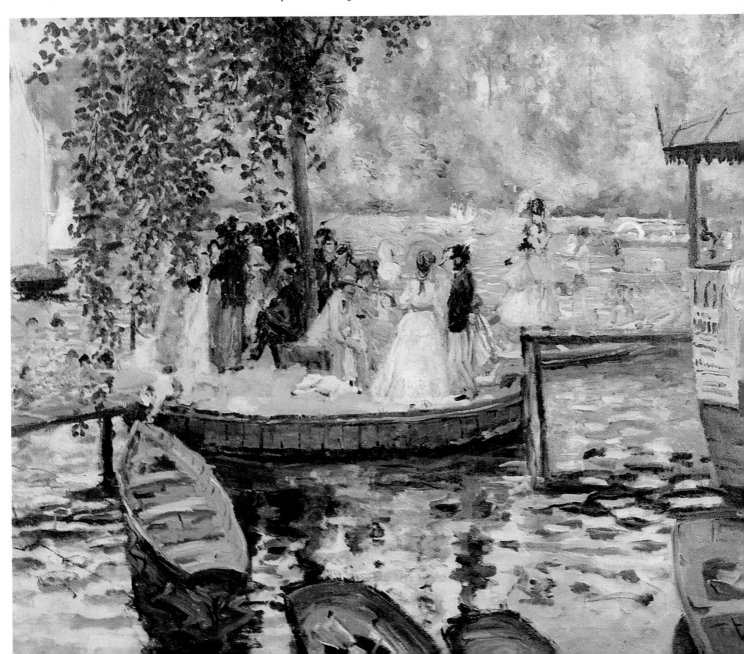

It was Boudin who offered him the necessary introductions in Paris, one of whom was Constant Troyon, who perceived the charm with which the young artist was able to portray a scene, but who also recognized the compositional flaws and the need for some serious study. Troyon was one of the Barbizon school of painters who worked on the edge of the Forest of Fontainebleau, led by Theodore Rousseau; Monet himself would one day work there and it is likely that the Barbizon painters set the stage for the Impressionist movement, which would follow several years later.

On the strength of Troyon's criticism, Monet's father reluctantly agreed to finance a period of learning in Paris. In order to curry favour with his family, Monet enrolled in the Académie Suisse, a small private art school where he met Camille Pissarro. Monet simply wasn't inspired by the strictures of training. He wanted to learn first hand; most importantly, he just wanted to *paint*. He left shortly after, but remained friends with Pissarro. Monet liked to paint with his colleagues, to work out of doors. Landscape painting was considered wildly inferior to the more established categories of painting, but he would relentlessly pursue it, in defiance, perhaps, of everything that was believed to be important about art in those days.

Monet's lust for painting was firmly checked by two years in military service in Northern Africa. He returned, at the age of twenty-two, weakened by typhoid fever, but more determined than ever to succeed as an artist. While convalescing at Le Havre, he met the Dutchman Johan Barthold Jongkind, a landscape painter whose evocative and fresh style had been admired by Monet and Boudin for many years. Monet was enormously inspired by Jongkind and he later wrote that Jongkind had completed the 'education of my eye', and indeed the older artist played an important role in the development of the technique which would eventually characterize Impressionism, with exquisite studies of the effects of air and atmosphere, painted in the *plein air*.

For financial reasons, Monet grudgingly agreed to take up academic study again, in order to receive some financial support from his father, but he lasted only a few weeks. He entered the studio of Charles Gleyre because he was a respected academic master, and because he didn't expect too much from his students; it was understood that Gleyre encouraged individuality, and Monet was in favour of that. But in principle, Monet despised the academic tradition, and he felt he had nothing to learn from the Swiss-born Gleyre.

Pierre-Auguste Renoir, Alfred Sisley and Frédéric Bazille were drawn to the studio of Charles Gleyre for much the same reasons as Monet and the four became firm friends, their inspired ideology drawing the first breath of the movement that would become Impressionism. Gleyre had a reputation for relaxed principles and teaching methods,

The Red Roofs, Pissarro, 1877
(Musée d'Orsay, Paris). Pissarro's work was less popular than that of his colleagues, partly because he refused to paint idealized landscapes. He was determined to portray life honestly, as it really existed.

and he was also a less expensive option for what was, on the whole, an impoverished group of artists. Bazille and Sisley had some money behind them – in particular, Bazille would, until his untimely death in the Franco-Prussian War, support both Renoir and Monet when they had trouble eking out a living from their work – but Renoir came from a working-class family who were unable to contribute in any way to their son's education, and Monet was frequently out of favour with his, so that both were required to live meagrely, and often on the generosity of their friends.

Villeneuve la Garenne, Sisley, 1872 (Hermitage Museum, Leningrad). Throughout his career Sisley painted virtually nothing but landscapes; nature offered him a release, an emotional outlet. He wrote later, 'Although the landscape painter must always be master of his brush and his subject, the manner of painting must be capable of expressing the emotions of the artist.'

Monet's colleagues were in general more disciplined and perhaps more bohemian than he, but they enjoyed his eccentricities. Renoir described Monet as a 'dandy' to his son Jean who wrote, in his book, *Renoir on Renoir*:

He didn't have a sou, but he wore shirts with lace cuffs. To one student who was making up to him, a pretty but vulgar girl, he replied: 'I'm sorry but I only sleep with duchesses or maids. Anything in between I find revolting. The ideal would be a duchess's maid.'

The youngest of the Impressionists, Pierre-Auguste Renoir was born on 25 February 1841, in the French town of Limoges. His family moved to Paris when he was only four, and he always considered

himself a Parisian, despite the fact that his roots lay further west. He was sixth in a line of seven children, born to a tailor, Leonard Renoir, who struggled in a climate of ever-changing technological advances to keep his young family in food and lodgings. In Paris, their home was a small apartment, curiously situated between the Louvre and the famous Tuileries gardens, which allowed the young Renoir access both to the great paintings which would later inspire him, and the splendid gardens of King Louis-Philippe, which kindled the great love of gardens that was shared by many of the Impressionists.

Renoir's parents recognized his superior gift for art and he was apprenticed to a porcelain painter. Porcelain painting required a keen eye and a delicate brushstroke, both of which were fostered in Renoir and would later become emblematic of his style. Renoir was just thirteen when he began his apprenticeship, and he remained there for four years, until the costs of handpainting porcelain became uneconomical and the industry ground to a halt.

Throughout his life, Renoir rebelled against the advance of technology, nurturing instead an overwhelming interest in and love for things basic, simple and beautiful. He felt that technology had robbed society of its artisan conventions and that machine-produced goods were lacking in integrity; from that time he sought to restore the balance through his art. He later wrote, 'The segments of an orange, the leaves of a tree, the petals of a flower, are never exactly identical. It would seem that every type of beauty derives its charm from its diversity.' He sought to establish a new refinement in art; one which defended imperfection.

Renoir's apprenticeship left him some idle time, and he studied drawing under the sculptor Callouette. After a short career painting blinds, awnings and murals for cafés Renoir managed to put aside some money. He longed for a career in art, but his working-class background forbade the kind of life required by a serious artist. Very few artists were able to make a decent living, or indeed live at all on what they earned from their work. Despite the daunting prospect of a penniless existence, Renoir left his regular jobs and in 1862 he was accepted at the Ecole des Beaux-Arts. He stumbled upon the studio of Charles Gleyre, where he shared with his colleagues the delicious freedom that a career of painting brought to them. To be an artist in the mid nineteenth century was a romantic and indulgent move and of all his friends Renoir alone depended almost entirely on the money he had earned as a tradesman so that when that money ran out he often went without food.

It was, however, an enormously fulfilling life; the young men spent their time and their creative energies on a job they loved, lived and breathed. The realities of the world around them were rarely allowed to encroach on the sheer pleasure of painting, that is, when there was money for paint and canvas. Even when their reputations

were established, they did without many necessities. Renoir later wrote to Bazille, 'We don't eat every day. Yet I am happy in spite of it, because, as far as painting is concerned ... I do almost nothing because I have no paint.'

Bazille, Sisley, Renoir and Monet began painting out of doors, particularly in the forest of Fontainebleau, where they became enchanted by the potential offered by nature. They studied the effect of the light and atmosphere, and how it changed with the weather; it was a fascination which would become the mainstay of much of the Impressionist movement, and which would captivate Monet, in particular, for the rest of his life.

It was here, in 1863, that Renoir met the ageing painter Diaz de la Pena, whose forest scenes had won him a place with the Barbizon painters. Diaz, too, was interested in portraying the impression of sunlight through the trees and after his chance meeting with the artist, Renoir credited him as his first great influence. It was Diaz who suggested that Renoir lighten his palette, removing black entirely, which changed the nature of his work and the course of his art from that time onwards.

The third member of the group of budding artists, Frédéric Bazille, was born in 1841, the son of a prosperous wine-maker. His family was cultured, and Bazille had grown up surrounded by art and encouraged by his parents' belief in its ultimate importance. Bazille began to study medicine, but was distracted three years into his studies by his growing enjoyment of painting. He had begun to spend time at Gleyre's studio, where he met Renoir, Monet and Sisley, and when he eventually failed his medical exams, he turned to art as a career, subsidized by his parents. Bazille was a tall, lean man, with a warm heart. Throughout his short career he generously helped to support his colleagues in their frequent times of financial troubles. Bazille's friendship with Monet in particular was strong, and he was greatly influenced by Monet's already opulent use of colour in his work.

Bazille was more concerned with form and composition than were Renoir or Monet; indeed, he was never comfortable painting directly from nature, preferring instead to work from a series of sketches. The final painting was rendered in the open air, but the majority of the thought behind it had been undertaken in the studio. He wrote, in 1868, 'I would like to restore to every subject its weight and volume, and not only paint the appearance', an indication that his ideology was, as suggested by his biographer F. Daulte, more post-Impressionist than Impressionist. But Bazille was as affected as his contemporaries by the close-minded strictures of the Salon, and he was one of the first to suggest the possibility of an alternative exhibition to show their work.

Boulevard des Capucines, Monet, 1873 (Nelson-Atkins Museum of Art, Kansas City). The subjects of Monet's famous painting, which hung at the first Impressionist exhibition, were registered with tiny daubs and flicks of paint, presenting a hazy impression of a moment in Paris' heyday. The critics scorned it.

Poppy Field, Monet, 1873
(Musée d'Orsay, Paris). Monet's first wife Camille, and their son, Jean, are the subjects of this elegant painting, which was completed a year before the first Impressionist exhibition.

Bazille was unconcerned by a lack of financial success, since it was unnecessary for him to make a living from his painting. He wrote to his parents in 1866:

I have tried to paint, as well as I can, the simplest possible subjects. In my opinion the subject matters little, provided that what I do is interesting as painting. I have chosen to paint our own age because this is what I understand best, because it is more alive, and because I am painting for living people. So of course my paintings will be rejected.

Sadly, Bazille's life was cut tragically short and his promise never fully realized. It is impossible to guess the impact he may have had if his talents had been given the opportunity to mature.

Alfred Sisley was the final member of the original four; he was born in Paris, in 1839, of British parents, and he was educated there and in London. His father ran a successful export company, and his mother was highly cultured. Sisley was surrounded by the arts from his earliest years, but was encouraged to follow business pursuits. In London, at eighteen, Sisley threw himself into his commercial career, but spent his spare time enjoying the works of Turner, Constable and Bonington, all of whom excited in him a growing love of landscape, of nature and the pure and unfettered means by which they could be portrayed. He returned home in 1862, whereupon he entered the studio of Gleyre, determined to paint as a career.

Gleyre's ideology reflected very much that of the establishment, and he considered landscape to be a 'decadent art'. Sisley was not prepared to believe this, having witnessed first hand some of the finest landscape paintings in the world, and his time at the studio was short-lived. His friendship with Renoir, Monet and Bazille, however, was much more long-lasting, and despite their varying backgrounds and beliefs, the men became firm friends and painting partners.

Sisley lived near Paris for most of his early career, alternating between outdoor painting (much of it in the forest of Fontainebleau with his friends) and his studio. His painting was financed by his parents, and he was a relaxed, well-dressed and charming man. His great fondness for women was legendary; Renoir later told his son Jean that Sisley 'could never resist a petticoat. We would be walking along the street, talking about the weather or something equally trivial and suddenly Sisley would disappear. Then I would discover him at his old game of flirting.'

Sisley married in 1866, and fathered two children, enjoying the casual lifestyle of a cultured gentleman of some means. In 1871, however, Sisley's father's business collapsed and overnight Sisley found himself having to support his wife and young children by painting alone. He struggled to make ends meet, standing by his implicit belief in the significance of his art, and vowing not to bend his integrity to popular tastes, but becoming suddenly a professional artist and not just a lover of art.

The four friends had varying success at the Salon. All earnest young painters, they envisioned fine careers for themselves and in the early years they clambered along the traditional path to fame and good fortune. Monet's first submissions to the Salon were accepted: *Cape La Heve at Ebb Tide*, and *The Mouth of the Seine at Honfleur* in 1865, and *Camille* and a further seascape in 1866. Flushed with his early success, he began to undertake more challenging paintings, all of which were rejected.

Renoir had *Esmeralda Dancing with her Goat* accepted in 1864, and later, his famous portrait of Sisley with his wife, called *The Engaged*

Couple (1868), but subsequent pictures were rejected, and he began to lose heart. He relied more than any of his friends on the sale of his works, and none appeared to be forthcoming.

At this time, Sisley still had his father's wealth to fall back upon, and prior to 1870, he finished very little, working long hours on his paintings, but indulging his love of art by experimenting with technique and colour, simply glorying in the ability to recreate everything that was beautiful around him. His early work was somewhat flat, but towards 1870 he began to adopt the Impressionist technique, with a lighter palette, looser brushstrokes and the spontaneous splashes of colour which brought alive his landscapes. Like Monet he was fascinated with the effects of light on water, and throughout his career he experimented with colour as a way of capturing its multitude of forms.

Bazille's work was almost always accepted at the Salon, from 1866-70, partly because of his excellent draughtsmanship, but also because of his intuitive skills of composition. *The Family Reunion* was accepted at the Salon in 1868, and it has been likened to Monet's *Déjeuner sur l'Herbe*, painted outdoors, with a brilliant play of colours used to render the dappled effect of light through the trees. He also painted *View of a Village,* shown in the same year, a clear indication that he found light as fascinating as the rest of the budding Impressionists.

Pissarro was another keen young painter, intent on working with the Impressionists, whom he had befriended, quite early on, having studied with Monet at the Académie Suisse. Camille Pissarro was born in 1830 in the West Indies, the son of a Creole mother and a Portuguese-Jewish father. His family was well-off, and he was able to choose art as a career, safe in the knowledge that it could be subsidized by his parents. He studied art in Paris, first at the Académie Suisse, and then on the streets of Paris itself. Emile Zola wrote of him, 'You are a great blunderer, Sir: you are a painter whom I like.'

Paul Cézanne, a later convert to Pissarro's ideology and a painter who reflected his extraordinary influence, called him a 'humble and colossal man'. In *Modern French Masters*, Pissarro is described as being:

> *... by political conviction a socialist-anarchist, and an avowed atheist, but there was no hate in him. He was a quiet, gentle man who was held in the highest esteem by all his friends. He was a gifted teacher who had a deep respect for the opinions and personality of others. In a letter to his artist sons he said, 'What I fear most is for you to resemble me too much. Accept only those of my opinions that are in accord with your sentiments and mode of understanding. Be bold then, and to work!'*

Pissarro's work had been consistently chosen by the jury of the Salon for inclusion in exhibitions from 1860–70, but he chose to

Lady at the Piano, Renoir, 1875 (Chicago Art Institute). Renoir loved to paint scenes of everyday life, and he never sentimentalized his subjects. His friend Monet had already begun to concentrate on landscapes, while Renoir always felt more comfortable painting figures.

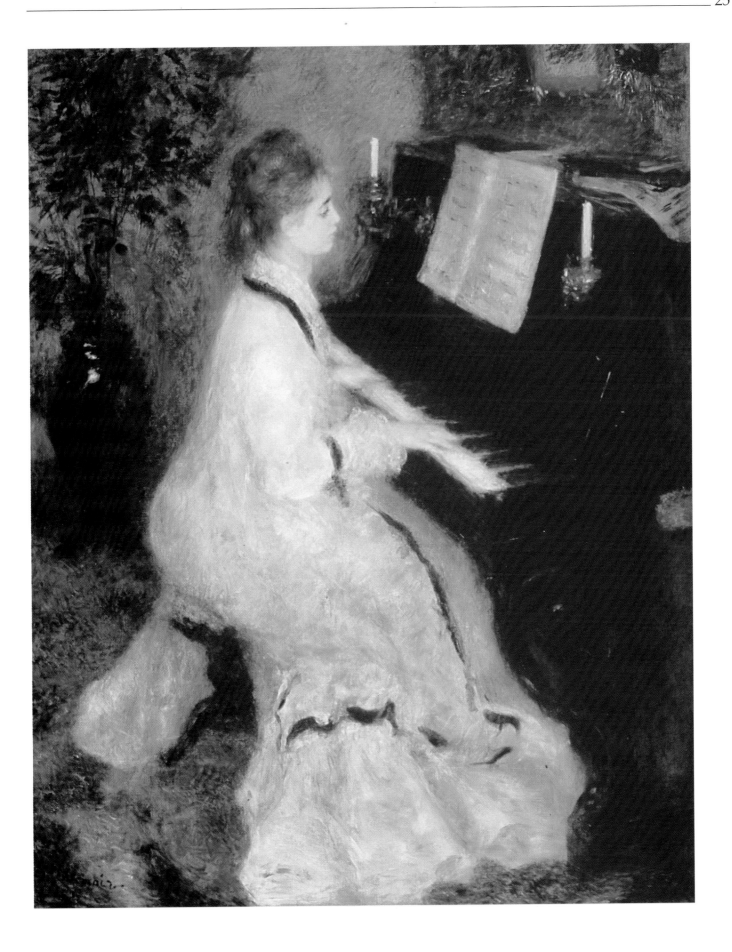

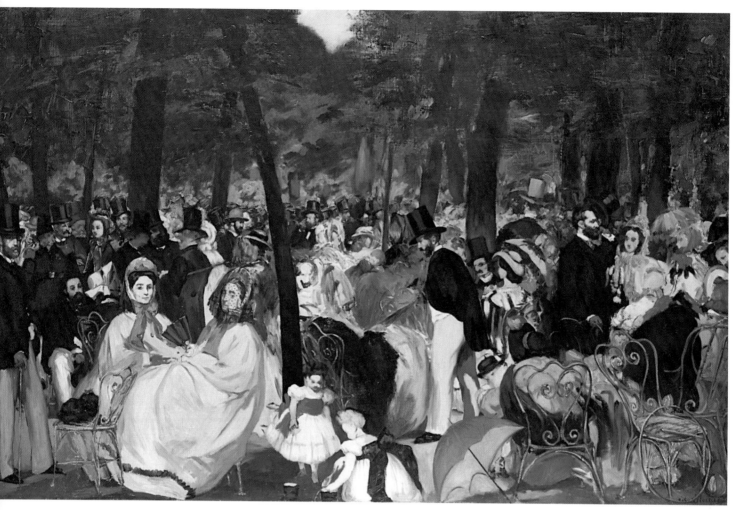

Music in the Tuileries, Manet, 1862
(National Gallery, London). This
painting was an important influence in
the development of the Impressionist
style. Manet had made a statement by
painting scenes of the society in which
he lived. He used colour in a new way,
suggesting rather than defining his
subjects, a technique which inspired
painters like Renoir and Monet.

support the beliefs of his friends and fellow painters. It was this loyalty
to the flowering Impressionist movement which would ultimately rob
him of his rightful claim to success.

Pissarro painted landscapes, mainly, not cottagey, idealistic
works, but richer, earthier subjects, like peasants working cabbage
fields, or urban landscapes in which every man is accorded his unique
perspective. He painted out of doors in all weathers, as eager as his
contemporaries to capture the elusive effect of light.

By the late 1870s, the allure of painting outdoors had become an
obsession for the young artists. Monet and Renoir were particularly
enchanted by the potential of a place called La Grenouillère and it was
here that the first whispers of Impressionism made themselves heard.

La Grenouillère, on the River Seine, near Paris, was a favourite
outdoor café, bathing spot and meeting place. Within commuting
distance of Paris, it was a popular haunt for city-dwellers and country
folk alike. Monet and Renoir often worked here, their easels nearly
touching, painting the same scenes over and over again. These are the
paintings that set the standards for everything that Impressionism
would become – lively, open-air scenes of everyday life, rippling with

life, light, colour and laughter.

These pre-Impressionist paintings had the spontaneity of a photograph, without the heavy contours and shadows of the Realist school of art. The artists attempted to recreate the effect of a brief period of time with daubs of colour and light that represent clearly the light and atmosphere of that moment. Accents of colour replaced drawing, and touches of paint took the place of any kind of formal structure. Critics of the day considered these paintings to be crude and unfinished.

Monet wrote to Bazille in Autumn of 1869, outlining his plans for the next Salon exhibition: 'I do have a dream, a painting of the bathing place at La Grenouillère. I have made a few poor sketches, but it is no more than a dream. Renoir, who has just spent two months here, also wants to paint the same picture.' These sketches were never changed to become great works; instead, unchanged, they are the quintessential paintings of the Impressionist movement.

Monet would become obsessed with painting out of doors, with capturing every aspect of light and atmosphere. While Renoir continued to paint landscapes, he found more pleasure in people and much of his work was characterized by the human form. Renoir's style differed from Monet's and their paintings, even those worked at the same moment, are immediately identifiable as their own. Renoir was fascinated by the techniques and inspiration of both his contemporaries and past masters, which he imbued with his own particular passion. He loved to paint; he experimented, emulated, took risks. It was a sensual experience; small erotic brushstrokes, tempered by long caressing sweeps of paint. He said, 'It's with my brush that I make love. My pictures should make me want to stroll in it, if it is a landscape, or to stroke a breast if it is a figure.'

The seventies were tough years financially, but a spirit of optimism was cultured by this dedicated band of artists. The painters expressed a *joie de vivre* that was fast becoming an important aspect of their generation. These vigorous and exciting days, however, were to come to an abrupt end. On 19 July 1870, the Franco-Prussian War was declared. Monet and Pissarro left the country. Renoir nearly lost his life. Sisley found himself very much on his own financially, with a family to care for and no concept of how to forge his way in the real world. Bazille was shot dead in the battle of Beaune la Rolande, eight days before his twenty-ninth birthday.

Their glittering world had lost its sparkle, and they had no idea how to restore it.

CHAPTER 2

Making an Impression

Art is a vice. One doesn't
take it in lawful wedlock,
one rapes it.

Degas

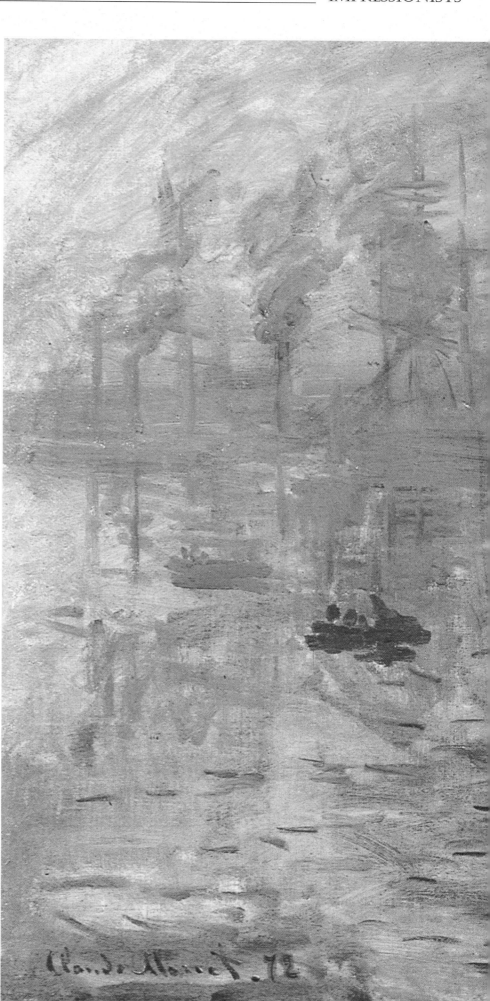

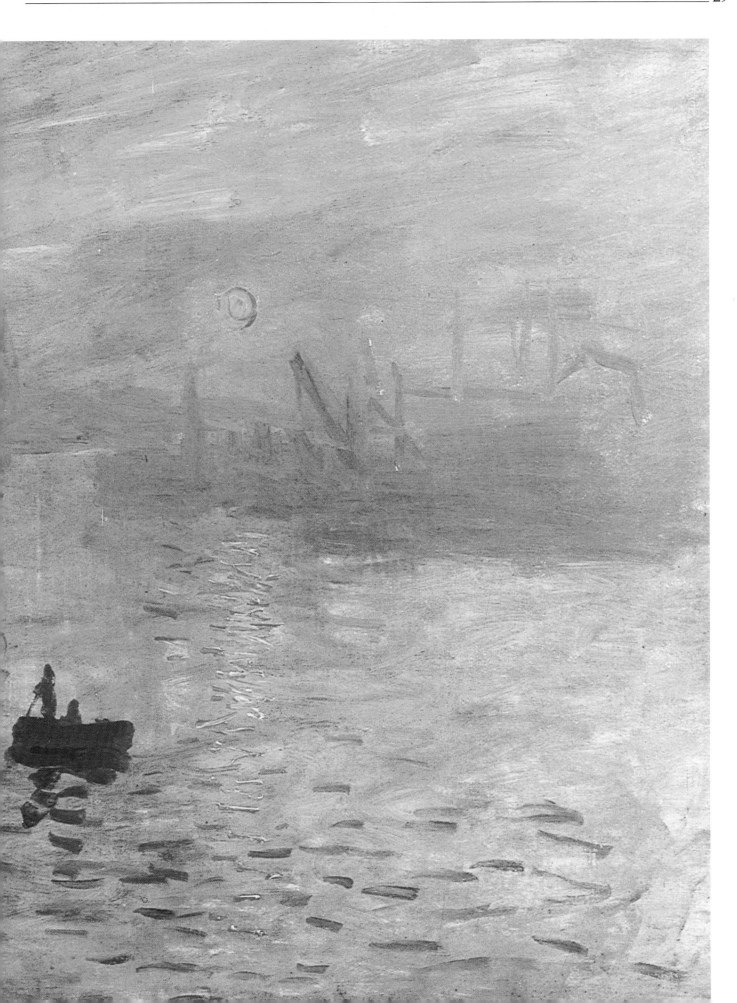

Overleaf:
Impression, Sunrise, Monet, 1872
(Musée Marmottan, Paris). Monet
struck upon the name for this painting
on impulse, just before the first
Impressionist exhibition opened. It was
this painting which inspired the name
Impressionism.

In 1863 the Salon had rejected so many submissions that the outcry
led Napoleon to create a Salon des Refusés, an alternative exhibi-
tion where the work of those who had been refused by the Salon
could be hung. The exhibition was placed alongside the official show,
and met with a varied critical response. Edouard Manet stole the show
with his *Déjeuner sur l'Herbe*, a summer picnic set in the woods, in
which two businessmen are entertaining two nude women of ques-
tionable virtue. Manet's painting caused such a stir that it brought him
instant notoriety. Napoleon himself suggested that it 'offends against
modesty', and in *Le Jury et les exposants*, Louis Etienne wrote:

> *A commonplace woman of the demi-monde, as naked as can be,
> shamelessly lolls between two dandies dressed to the teeth ... This is
> a young man's practical joke, a shameful open sore not worth
> exhibiting this way.*

Emile Zola, however, defended the work, noting:

> *The public was scandalized by the nude, which was all it saw in the
> painting. 'Good Heavens! How indecent! A woman without a stitch
> on alongside two clothed men.' Such a thing had never been seen
> before! But that was a gross mistake, for in the Louvre there are more
> than fifty canvases in which both clothed and nude figures occur.*

Manet became the *enfant terrible* of art, but he was a guru among
the young Parisian painters, who delighted in his fresh approach;
Manet used paint with gay abandon and subjects that were natural, set
in the present and dressed accordingly. Manet had found a champion
in the writer and poet, Baudelaire, and the young Impressionists were
converts to his developing ideology. It was partly Manet's one-man
show in the gallery of the famous dealer Martinet, in 1867, which
inspired Monet, Sisley and eventually Renoir to leave the Académie
Gleyre, in order to paint without supervision.

From 1866, Manet also began to frequent the Café Gúerbois. Many
of the painters who came to be associated with the budding
Impressionist movement met here, including Renoir, Sisley, Gustav
Caillebotte and Monet, a group often called the Batignolles group. Café
Gúerbois was situated in the Batignolles region of Paris, where many
artists and writers lived and worked. Manet was the centre of evening
gatherings at the café, where animated discussions on modern art and
literature, among other things, took place.

The Impressionists' fascination with the modern-life theme often
focused on the contemporary urban world of leisure and entertain-
ment and Paris was the hub of that world. Manet was friendly with
various controversial writers, including Zola and Astruc, and like

Opposite:
**Bath: Woman Drying Her Feet, Degas,
1886** (Musée d'Orsay, Paris). Although
Degas claimed not to be Impressionist,
he was instrumental in assuring their
final success. He painted in his studio,
after making dozens of sketches of his
subject, but his rendering of light within
a painting is clearly influenced by the
paintings of his colleagues.

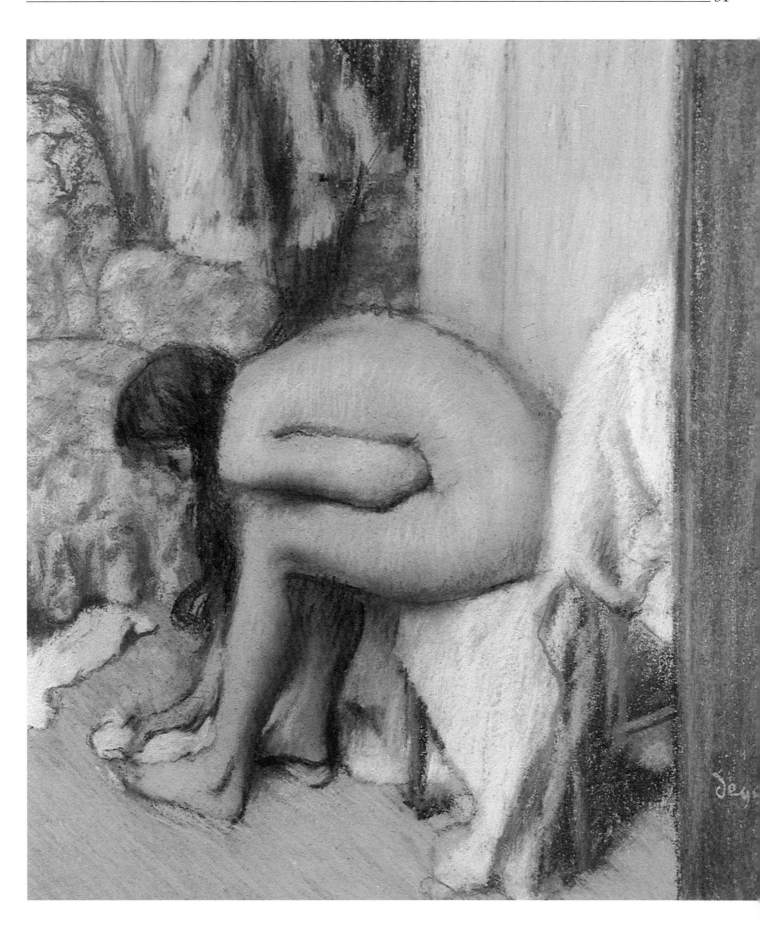

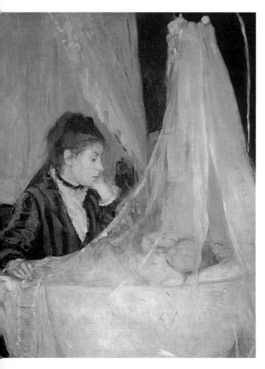

The Cradle, Morisot, 1873
(The Louvre, Paris). Berthe Morisot gave up a career at the Salon by exhibiting with the Impressionists. This painting imposes the Impressionist style on a domestic setting. She enjoyed painting women and children; the subjects here are her sister Edma and her new baby.

many of his contemporaries, he enjoyed battling out the emerging doctrines of their age. Until his death, Bazille attended the café almost daily, along with Degas, Fantin-Latour, Maitre, Guys, Cézanne and Pissarro, all of whom made visits while in Paris. Monet in particular welcomed the stimulation afforded by these evenings, but was somewhat daunted by the vigour with which every issue was addressed. In 1868 he wrote to Bazille commenting on his disillusionment:

> *One is too taken up with all that one sees and hears in Paris, however strong one is, and what I do here will at least have the merit of being unlike anyone else, at least I believe so, because it will simply be the expression of what I, and only I, have felt. The further I get, the more I regret how little I know, that's what hinders me the most ...*

Manet was a fascinating and sociable man, dominating these evenings with an assertive and quick wit. In *Au Pays du Souvenir*, Silvestre wrote:

> *This revolutionary – the word is not too strong – had the manners of a perfect gentleman ... he had in the extraordinary vivacity of his gaze, in the mocking expression on his lips ... a very strong dose of the Parisian street urchin. Although very generous and very good-hearted, he was deliberately ironic in conversation and often cruel. He had a marvellous command of the annihilating and devastating phrase.*

The Impressionists were, in general, not a political group, although they relished the freedom of opinion brought about in the *belle époque.* They held diverse views on most matters, but shared the same aims with regard to their work. Each was becoming dissatisfied with the process by which paintings were chosen for exhibition at the Salon, and the fact that their work was increasingly rejected. They sought an answer to the dilemma of the outdated jury system, and had begun to consider the idea of yet another alternative exhibition.

The Franco-Prussian War had extinguished earlier plans for such a show, but by 1874 the time seemed ripe to plan something independent, aimed at those artists who painted what they described as 'nature and life in their larger realities'.

A large selection of artists was to be included, partly because the show was to be funded by the contributors themselves, and partly because the organizers felt that artists who had already achieved some critical acclaim would lend credibility to the venture. Renoir suggested the name for the group: *Société anonyme des artistes, peintres, sculpteurs, graveurs, etc.* For a monthly subscription of five francs, artists could exhibit and sell their paintings. There would be no selection process,

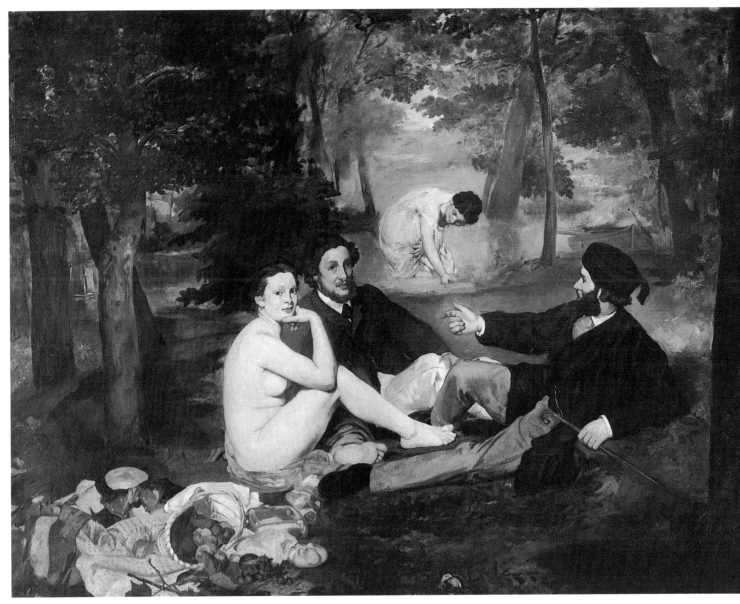

but there would be a committee presiding over the society, to ensure its smooth running. The first such committee included Pissarro, Edgar Degas, Sisley, Berthe Morisot, Armand Guillaumin, Edouard Beliard, Renoir and Monet, among others.

Degas was a new convert to the Impressionist dogma, vigorously defending the group's right to present their ideas to the public, although not undertaking much of the technique himself. Degas was a fascinating and compelling man, and he supported the idea with indefatigable passion.

Born Hilaire Edgar Germain de Gas in Paris, on 19 July 1934, Degas, as he later became, was the eldest of five children. He studied law briefly before deciding to become a painter, and gave up a considerable family fortune to do so, although his father was later impressed by his dedication and began to support him once more. He

Déjeuner sur l'Herbe, Manet, 1863
(Musée d'Orsay, Paris). Hung at the Salon des Refuseés in 1863, this painting was considered immoral and shocking. Manet became the *enfant terrible* of the art world, greatly admired by the group of young artists who would become the Impressionists.

The House of the Hanged Man, Auvers (La Maison du Pendu), Cézanne, 1873 (The Louvre, Paris). This painting was hung at the first Impressionist show. Cézanne painted it a year earlier, when he was in Auvers-sur-Oise with Pissarro, whose influence is evident in the brushwork.

was famous for his intellectual energy, and his sharp retorts, a favourite among the crowd at the Café Gúerbois, and consistently well regarded by both the establishment, the critics and the public. Linda Bolton, in her Introduction to *Degas*, wrote about:

> *Degas' contradictory nature: a reactionary with radical ideas, an anti-Semite whose closest friend were Jewish, and a misogynist whose life was spent observing and painting women ... Demanding, difficult and exacting, Degas commanded reverential respect among a small group of close family friends, who put up with his authoritarian stipulations, such as ... for dinner: 'There will be a*

dish cooked without butter for me. No flowers on the table, very little light ... You'll shut up the cat, I know, and no one will bring a dog. And if there are women there, ask them not to put smells on themselves ... Scent, when there are things that smell so good! Such as toast, for example. And we shall sit down to table at exactly half-past seven.'

He shared with the Impressionists a feeling for the contemporary subject matter, and in painting techniques, including the portrayal of light. He did not, however, paint landscapes, other than two series, and he preferred using line to achieve effect rather than the characteristic use of colour of the Impressionist group: 'I am a colourist with line,' he said. He also painted in the studio, preferring artificial lighting to that of nature. He chose to paint 'attractive ugliness', in, for instance, his *Bath: Woman Drying Her Feet* (1886). 'There is nothing less spontaneous than my art,' he said once, which belied his overwhelming involvement with the Impressionists.

What drove Degas most to support and indeed help to organize the first Impressionist exhibitions, was the implied challenge to establishment-led art. He was a born political reactionary, with no real cause. He caught the wave of the latest craze, and made it his own throughout his life. He wrote to Tissot, 'The Realist movement no longer needs to fight with the others ... It exists, it must show itself as something distinct. There must be a salon of Realists ... So forget the money side for a moment. Exhibit. Be of our country and your friends.' It was Degas who single-handedly convinced a large number of established artists to show in the first independent exhibition. Degas himself showed *Carriage at the Races* (1870–3).

A notable omission from the first exhibition was Manet, who sympathized with the aims of the group, but who felt that the Salon was the only 'true battlefield'. Following his hostile reception by the critics at the Salon des Refusés, Manet had received a degree of acclaim at the Salon; in particular, for his *Le Bon Bock* (1863), which had attracted the attention of the annual Salon review, *Revue des Deux Mondes*, which had ignored him throughout his entire career.

Surprisingly, Berthe Morisot, a great friend of Manet's and newly married to his brother, decided to exhibit with the group, and she lent great prestige with her inclusion. Manet had met Morisot many years earlier, while she was painting at the Louvre. She was one of only two women painters of note in the Impressionist group. She was from a wealthy family, and took her art very seriously. Her paintings were feminine in both subject matter, and her life with her husband, Eugène Manet, and her children can be traced through her work. An admirer wrote of her, 'The interesting thing about Berthe Morisot was that she lived her paintings and painted her life. As a girl, wife and mother, her

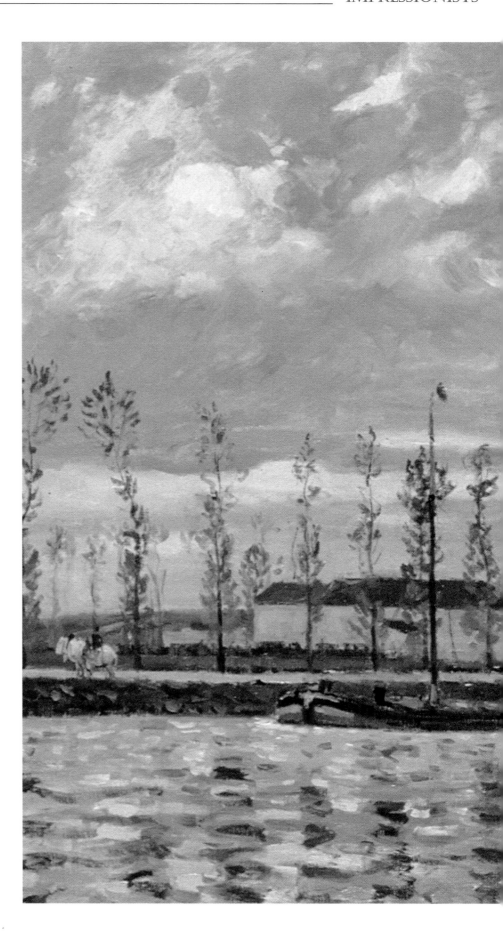

Lock at Pontoise, Pissarro, 1872
(Cleveland Museum of Art). Painted
following his return from London after
the Franco-Prussian War, this work
reflects the new maturity in Pissarro's
technique, which developed while he
was in England. He painted alongside
Monet in London, and their style
became quite similar at this point in
their careers.

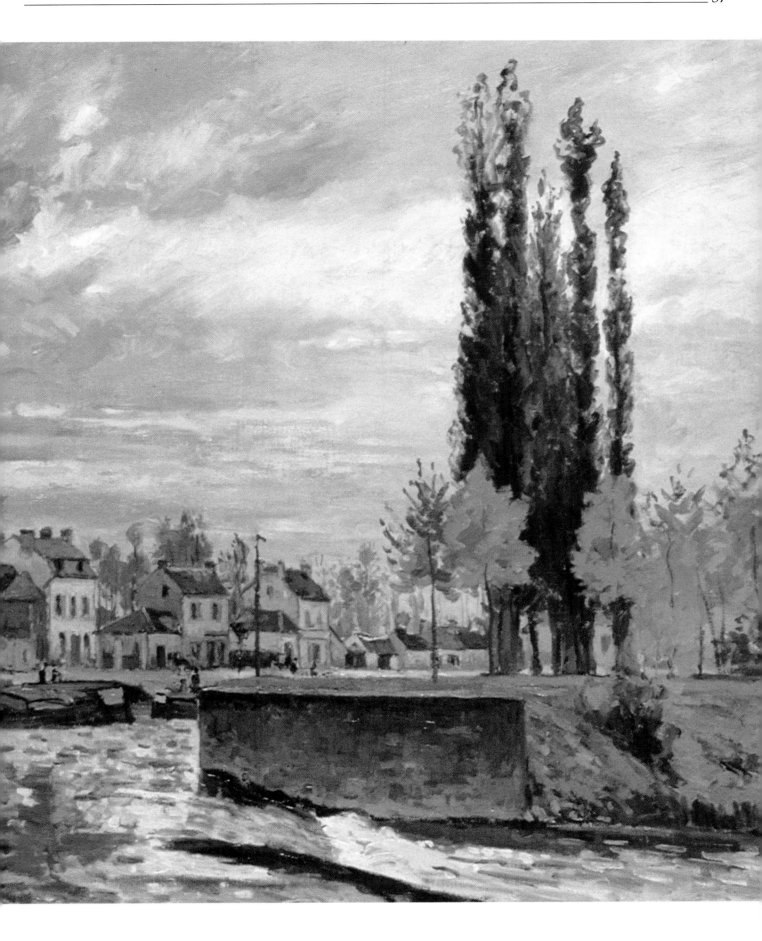

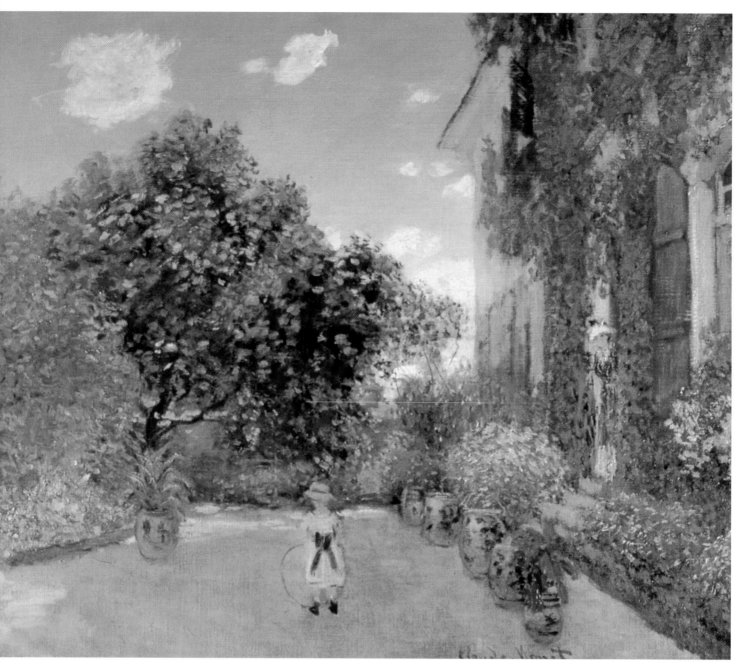

The Artist's Garden at Argenteuil, Monet, 1872 (Chicago Art Institute). Monet's gardens were cultivated to become the perfect backdrop for his paintings. This period of his life, at Argenteuil, was fairly prosperous. Following the first Impressionist exhibition, that situation was to change drastically.

sketches and paintings follow her own existence closely ...' Her technique was, however, aggressive and unfailingly confident, with a certainty of touch that was missing in many of her contemporaries.

She embraced the idea of an alternative exhibition, and although her work had been consistently represented at the Salon, she no longer exhibited there, choosing instead to show her work only at Impressionist shows. She missed only one, following the birth of her daughter in 1879. As a woman she was unable to attend the evening gatherings at the Café Gúerbois, but she soon ingratiated herself and later held a series of soirées for the group, bringing its members to her instead of insisting upon her inclusion in their café meetings. For the

first exhibition, she submitted *Hide-and-Seek* (1872–3), which was owned by Manet.

The alternative exhibition was scheduled to open on 15 April, two weeks before the official Salon. *Impression, Sunrise*, Monet's study of the port at Le Havre, painted in 1862, was only one of the works he exhibited, but it was this painting which caused the greatest stir.

Writing for the satirical magazine *Le Charivari*, Louis Leroy noted, 'Impression – too right! And I was just saying that if an impression has been made on me, something must be making it. What freedom and ease in the brushwork! Wallpaper in its embryonic state is more finished than this ...' The label was quickly adopted by others and within months had become an accepted term in the art world, defining the stylistic unity of the group.

Among other paintings exhibited by Monet at the first Impressionist exhibition was *Luncheon* which had been rejected for inclusion in the Salon exhibition of 1870, for being too bold and unprofessional. While the exuberant handling of paint is often attributed to Manet's influence (Manet's own *Breakfast in the Studio*, shown at the Salon in 1869, may have been Monet's inspiration), the painting confirms Monet's mastery of colour and light.

Monet also included *Boulevard des Capucines*, one of his most thought-provoking works. The painting was undertaken from the window of the photographer Nadar's studio, where the first Impressionist exhibition was held, and represents one of his most spectacular views of Paris. Richard Kendall comments on the significance of the work: 'Monet drew attention to the paradoxical relationship between art and observed reality, while at the same time making new claims for the immediacy and topicality of his art.'

Unfortunately, the critics in attendance failed to reach the same conclusions, labelling it crude and unfinished. In fact, Leroy, again in *Le Charivari*, blustered: 'Are you telling me that that is what I look like when I stroll along the Boulevard des Capucines ... Are you kidding?'

Renoir submitted *Dancer* which was appreciated by some critics, but Monsieur Leroy again said that although the artist was deemed to have an appreciation of colour, he lacked the ability to draw. Renoir had also chosen *La Loge*, *The Parisienne*, *Harvesters* and three works entitled *Fleurs*, *Tête de femme* and *Croquis* to exhibit, and they were surprisingly well received, in contrast to the critical attention paid to some of his colleagues. *La Loge* in particular garnered some acclaim. Renoir painted it in 1874, adopting the subject matter of his contemporaries, in this case that of Manet, whose influence on this impressionable group of artists seemed boundless.

Pissarro showed five works, including *Hoar Frost*, which was considered by Leroy to have 'neither head nor tail, top nor bottom, front nor back'. He also included *La Route*, *Effect of Winter* and *View of*

Pontoise. Cézanne was also represented with *The House of the Hanged Man*, and *Farmyard at Auvers*. Sisley supplied five paintings, including *Road at Saint-Germain* and *Island of Loge*.

In general, the few good reviews received were written by journalists who had been briefed about and were sympathetic to the aims and ideals of the painters; the remainder scorned the exhibition, confused perhaps by its unique perspective and vision. In his memoirs, dealer Paul Durand-Ruel wrote:

> *The public flocked to the exhibition, but obviously they were already prejudiced, and regarded these great artists as a bunch of ignorant, conceited fools who were displaying their eccentricities to get themselves noticed. There was a general upsurge of feeling against them in the public mind and an increase in the ridicule they had to suffer, extending to all reaches of society including the studios, the salons and even the theatres, where they were openly derided.*

Durand-Ruel was correct in his analysis of public opinion, but he did not mention the extraordinary vitriol which characterized the reviews. Comparatively few members of the public attended the

The Ball at the Moulin de la Galette, Renoir, 1876 (Musée d'Orsay, Paris). This entire work was painted on the spot at the famous dance hall at the top of the Butte Montmartre. Renoir painted it at the same time as *The Swing*, and both were recognized as works of great genius. Renoir was an unsurpassed documenter of the popular crowd scenes of French café society.

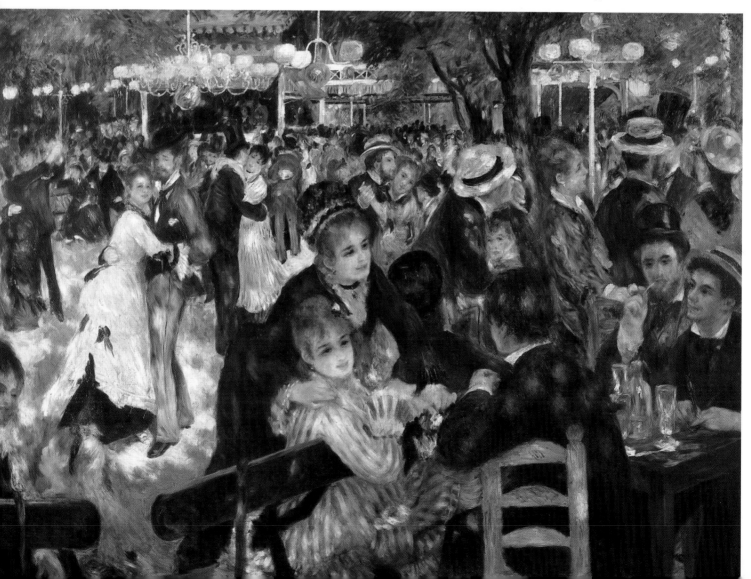

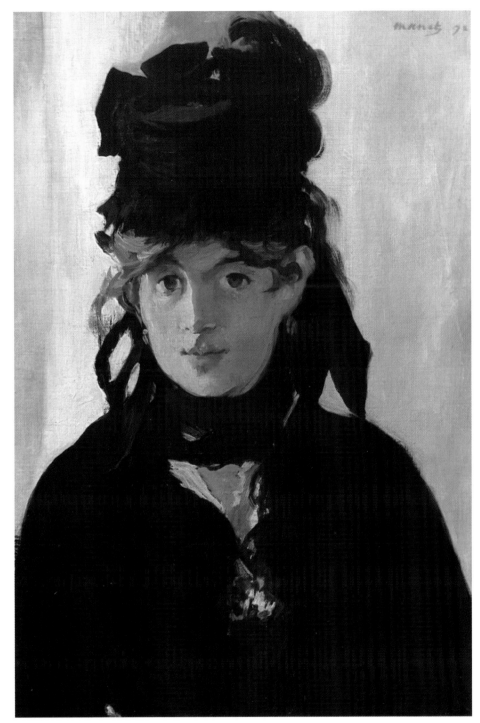

Berthe Morisot with Violets, Manet, 1872 (Private Collection). Morisot married Manet's brother Eugène the year of the first exhibition. She and Manet remained friends throughout their lives; he being her greatest inspiration and Manet finding her gentle calm uplifting.

exhibition; whereas the Salon would attract anything up to 3500 visitors a day, the Impressionists' first exhibition drew about 175. At the best of times, the French were notorious for reacting with hostility to anything different; it happened each year at both the Salon and the Salon des Refusés. But the animosity of the critics was unanticipated. While the term Impressionism became accepted among most critics, there was a faction who called the group 'The Intransigents', an expression which took its name from the radical political party that had

The Star, Degas, 1878 (Musée d'Orsay, Paris). The illumination of the dancer's dress is pure Impressionist, as are the loose, broken brushstrokes. This has become representative of the school, despite the fact that Degas denied being a member, and is one of the most famous works of all time.

attempted to take over the constitutional monarchy in Spain. The word came to mean anything that appeared to question the established order, and the Impressionists were seen by many to be an anarchic movement, threatening the existence of the established art tradition in France.

The critic Leroy called their work:

> ... *messy compositions, these thin washes, these mud-splashes against which the art lover has been rebelling for thirty years and which he has accepted only because constrained to do so ...*

Many of the artists failed to sell anything at all, and the paintings were auctioned the following year, to disappointing prices and reception. Another exhibition was not planned, but, in 1876, when the Salon once again rejected the works of those we have come to know as the great proponents of the Impressionist movement, another show was launched, this time in the gallery of Paul Durand-Ruel.

The second exhibition was disastrous. The Impressionists had gained in some quarters a reputation for being seditious, and many of the critics made no attempt to disguise their antagonism. Albert Wolff, writing for *Le Figaro*, said:

> *Some people burst out laughing in front of these things – my heart is oppressed by them ... These self-styled artists who call them-selves 'The Intransigents' or 'The Impressionists' take a canvas, some paint and brushes, throw some tones haphazardly on the canvas and then sign it. This is the way in which the lost souls of the Ville-Evrard [a notorious hospital for the mentally ill] pick up pebbles from the roadway, and believe that they have found diamonds.*

This time Renoir was singled out for *Nude in the Sunlight*. Wolff wrote, 'Try to explain to M. Renoir that a woman's torso is not a mass of flesh in the process of decomposition with green and violet spots which denote the state of complete putrefaction of a corpse!' The painting was in fact a precursor to the classic Renoir nudes, an elegant and sensual work which embodied the Impressionist fascination with light. Quite apart from the references to putrescence, Renoir's painting was also considered unfinished and unrealistic.

Le Figaro also wrote:

> ... *five or six lunatics, one of them a woman – a collection of unfor-tunates tainted by the folly of ambitions – have met here to exhibit their works ... what a terrifying spectacle is this of human vanity stretched to the verge of dementia. Someone should tell M. Pissarro*

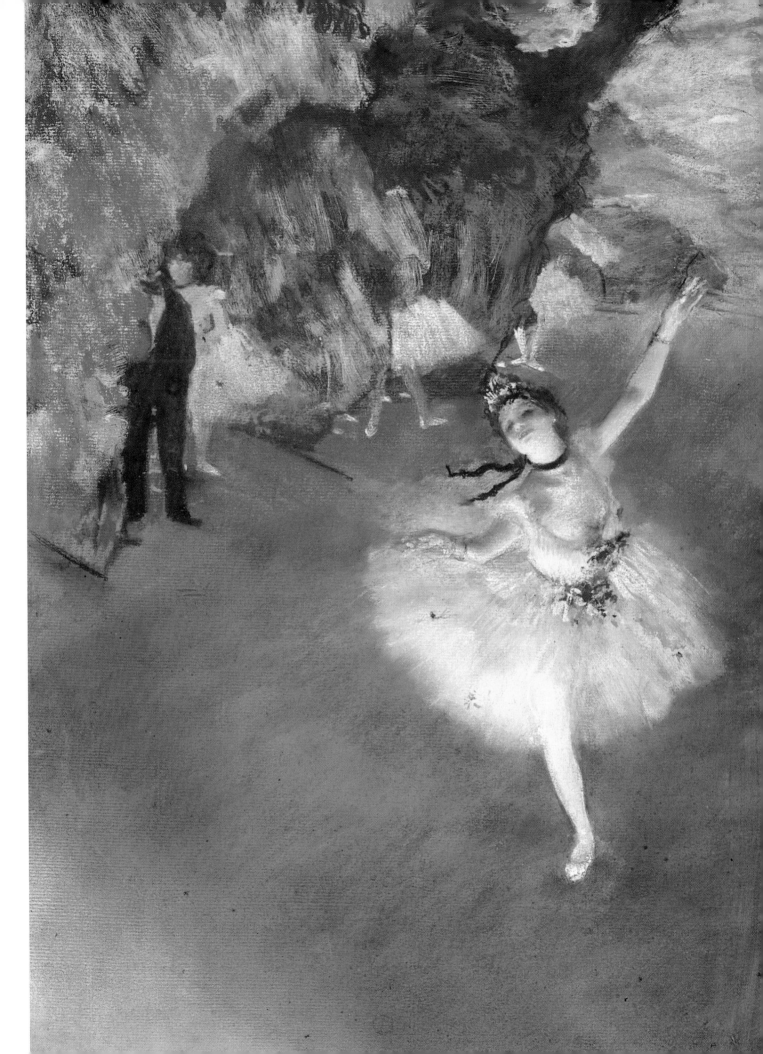

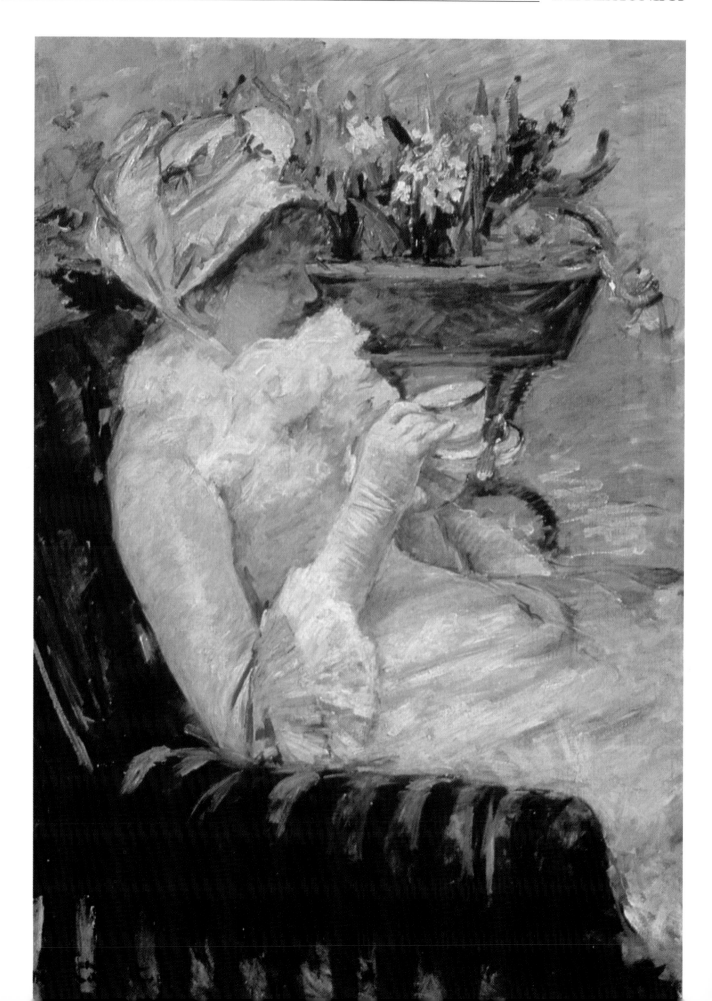

forcibly that trees are never violet, that the sky is never the colour of fresh butter, *that nowhere on earth are things to be seen as he painted them.*

There were, however, some grudging admirers of the style, and some, although they rejected the basic tenets of Impressionism, found it food for thought. Henry James, writing for the *New York Tribune*, thought the group was:

> *... decidedly interesting. But the effect of it was to make me think better than ever of all the good old rules which decree that beauty is beauty and ugliness is ugliness, and warn us off from the sophistications of satiety ...*

Many of the Impressionists were suffering enormous poverty through this period. Some, like Pissarro and Monet, often had no money for paint or canvases, yet their carefree paintings reflect none of the anxiety they must have been feeling. Monet wrote at that time:

> *... I can find no way out of it, the creditors are proving impossible to deal with and short of a sudden appearance on the scene of wealthy art patrons, we are going to be turned out of this dear little house ... I do not know what will become of us ...*

His Impressionist technique had matured and he captured the world around him at his home on the Seine at Argenteuil with unrestrained enthusiasm. *The Basin at Argenteuil* and *Regatta at Argenteuil*, both painted in 1872, represent the decreasing emphasis on reality in Monet's work; he sought more and more to capture the immediate impression, the essence of scene, rather than to document it with any accuracy. The result was a stunning new vocabulary of painting, where every syllable was represented with another dash of colour, a flamboyant and confident expression of what Monet actually felt.

He began a series of paintings in Paris – aggressive and oddly reverential portrayals of the *Gare Saint-Lazare*, which he travelled through each time he visited Paris from his home at Argenteuil. While Monet, like Renoir, hated the developments that arose with the Industrial Age, he was clearly fascinated by their tasteless modernity. The steam of the engines offered him a new perspective on shifting atmosphere, and the dirty air and gleaming metals and glass contrasted superbly under his brush. He applied Impressionist technique to this urban scene with the same ease that he captured every shift of light in nature.

Renoir's painting, too, had evolved to incorporate many of the elements which would eventually guarantee his success. At the sec-

The Cup of Tea, Cassatt, 1879 (Metropolitan Museum of Art, New York). Mary Cassatt was a firm follower of Degas. He asked her to join the Impressionists and she later said, 'Now I began to live.' She adopted their techniques and for many years her work was some of the most popular of the movement.

ond exhibition he had shown fifteen paintings, and there had been some quiet interest from the public, despite the almost universal damning. Durand-Ruel had also begun to buy his work, which he had ignored in the early seventies. Renoir was at a critical point in his career and he struggled to put on to the canvas the visions he was at last beginning to comprehend.

In 1876 Renoir rented a studio in the rue Cortot in Montmartre, where he produced some of his most famous works, such as *Le Moulin de la Galette, The Swing, Nude in Sunshine* and *Under the Arbour. The Swing* and *Le Moulin de la Galette* were painted simultaneously in the garden of his studio; he painted *The Swing* in the mornings and *Le Moulin* in the afternoons. Both paintings emphasize the firm grasp on Impressionism Renoir had achieved; the effect of light on his scenes is exquisitely rendered, redolent with the charm that would make his work so accessible and popular. The subject matter of both paintings was modern, a foray from the staid Salon-type paintings that Renoir had been accustomed to painting. In his garden at the rue Cortot, Renoir created a kind of pastoral world that fed his imagination, and challenged his perspectives. He surrounded himself with nature in the same way that he had surrounded himself with the paintings of the masters as a child. He sought inspiration there; used nature as his study.

Many of the Impressionists, among them Renoir's closest friends, had left Paris in search of the nature they longed to paint. Pissarro moved to Pontoise and then to Eragney. Monet and Caillebotte, an amateur painter and collector, and one of the greatest advocates of Impressionism, found solace in their respective gardens at Giverny and Petit-Gennevilliers. Renoir alone chose to remain in Paris, but he had found a stunning and overgrown sanctuary in his garden at Montmartre.

The seventies was a decade of growing success for Renoir. His studio at Montmartre was a hive of activity, becoming the central meeting place for many of his growing circle of acquaintances. He was one of the few artists among this circle to have achieved some financial success, and because he had not yet married and had no dependants, he had no responsibilities and was able to live quite happily on what he earned. His studio was just down the road from the Moulin de la Galette, an open-air dance hall situated at the base of the windmill from which it took its name, and his famous painting *Ball at the Moulin de la Galette* was painted on the spot.

Renoir loved the excitement and frivolity that distinguished this Parisian hall. *Ball at the Moulin de la Galette* is pure Renoir – radiant colours, throngs of festive merrymakers, twirling and gay on the dance floor. It took him six months to complete this painting, and he returned night after night in order to paint real-life dancers. The party was

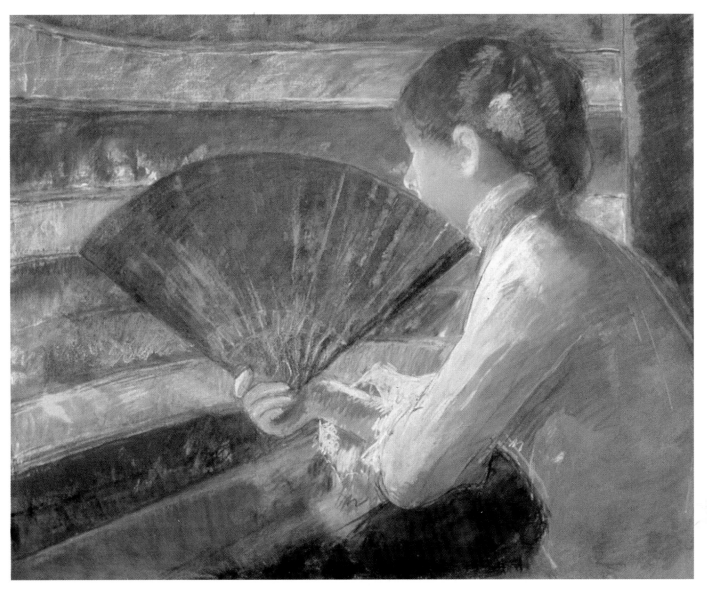

sketched on to unprimed canvas and he lost the earth tones of his earlier works, replacing them with vibrant blues and soft musty greys that brought the scene alive. The painting became Renoir's acknowledged masterpiece.

Renoir had remained friends with Degas, for whom support within the group was diminishing. Linda Bolton, in *Degas*, relates a conversation between picture dealer Paul Gimpel and Renoir, about Degas:

> *What a creature he was, that Degas, remarked ... Paul Gimpel to Renoir, who replied, All his friends had to leave him; I was one of the last to go, but even I couldn't stay till the end. The incomprehensible thing is that Monet, so gentle and affectionate, was always attacked, whereas Degas, so vitriolic, violent and uncompromising, was accepted from the very first by the Academy, the public and the*

In the Loge, Cassatt, 1879 (Philadelphia Museum of Art). Mary Cassatt was a determined and prolific artist. She worked from dawn until dusk every day, hardly breaking. She first showed with the Impressionists at their fourth exhibition, where this painting was considered a valuable addition to the group.

revolutionaries. People were afraid of him, was Gimpel's succinct answer.

Till his final days, Degas insisted that he was not an Impressionist. There are, however, arguments that his work adopted at the very least the emphasis on light that permeated the works of Monet, Renoir and Pissarro. But Degas remained firmly involved with the movement, even when many of the main proponents no longer paid attention. His appealing paintings of ballet dancers were painted in the 1870s, and the light reflecting on their tulles, the shimmer of net contrasting with satin bows, shadows marked in by colour and not contours, all betray the growing influence of the Impressionist group. The subtle effects of the tone and the contrast between the indistinct background and the exquisitely detailed ballerinas make these some of Degas' most popular works.

Like most Parisian gentlemen, Degas was a thrice-weekly visitor to the Paris Opera, and like the majority of his contemporaries it was the dancers who put on short performances in the intervals that he had come to see. When asked by an American collector why he had concentrated so heavily on the ballet, Degas replied, 'Because I find there, Madame, the combined movement of the Greeks.'

His sketches were made from life, and although the paintings were completed in the studio, their immediacy was not diminished. Paul Valery noted that Degas combined instantaneous 'impressions with endless toil in depth'.

Degas brought with him a new supporter in the form of Mary Cassatt, a friend and admirer of his work. An American, born in Philadelphia, Cassatt arrived in Paris the year of the first alternative exhibition. She saw a Degas pastel in a picture dealer's window and immediately recognized a kindred approach to art. Degas saw her work at the Salon that same year, and said, 'Here is one who feels as I do.'

Cassatt's work was rejected by the Salon in 1875 and 1877 and Degas suggested then that she join the Impressionists. She was delighted, saying, 'I hated conventional art. Now I began to live.' She quickly adopted the Impressionist use of colour, lightening her palette and using sharp, broken brushstrokes. Like Morisot, her themes were predominantly feminine; she enjoyed figure painting and scenes of mothers and babies, and children at play abound in her work. But she was never sentimental or cloying; indeed, her prime talent was for capturing an innocent moment and expressing it with pure regard on her canvas. Cassatt's dedication to her work was extraordinary. She painted from dawn to the late hours of every day, leaving little room for a personal life outside her art. She came to personify the Impressionist movement almost as soon as she joined it, with works like *The Cup of Tea* and *In the Loge* (1879) emphasizing all the qualities

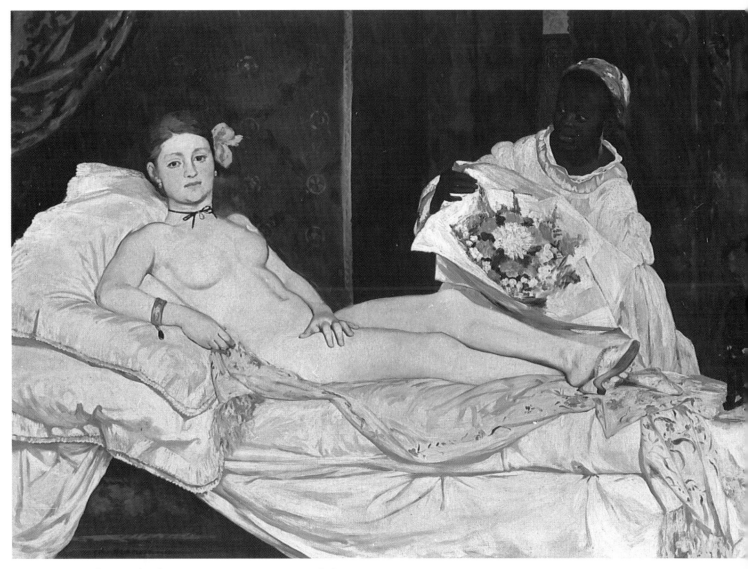

that eventually made the movement so successful.

Cassatt was very much the protégé of Degas, and her later work is certainly post-Impressionist in nature, at a time when Impressionism was thriving. Berthe Morisot, however, who painted with much less definition and emphasis on line, became increasingly Impressionist, revelling in the freedom the technique offered her. Her work has the same innate charm as Renoir's; the pleasure with which she painted enlivened her subjects. Her paintings had, despite the Impressionist label, sold consistently well, and because she was from a wealthy family, she was able to enjoy her art for its own sake, and not worry about providing for a family.

Sisley had become dependent on the dealer Durand-Ruel to support his work, and when it became clear that Durand-Ruel had over-extended himself, Sisley was left with virtually no means of survival. But his painting was developing in a unique manner – he had begun to focus on the use of motif in many works. The tree-lined road

Olympia, Manet, 1863 (Musée d'Orsay). Manet refused to show with the Impressionists, firm in his belief that the real battleground was the Salon. He showed this painting after *Déjeuner sur l'Herbe,* and the reaction was even more violent. His Impressionist colleagues adored it and it is considered one of the most important paintings in modern art.

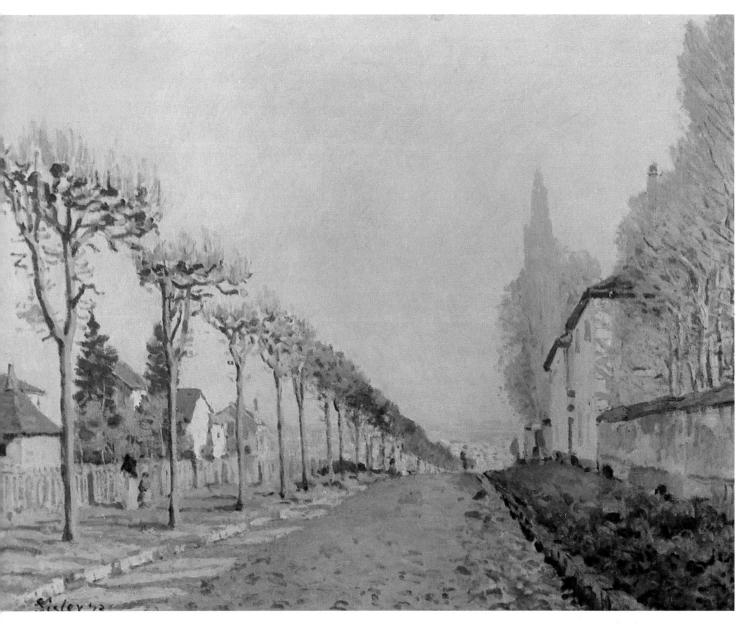

The Little Road at Sèvres, Sisley, 1873
(Musée d'Orsay, Paris). Sisley's use of
motif developed throughout his career.
From the earliest days he commonly
used tree-lined streets as a theme.
Sisley's biographer, F. Daulte, said, 'The
"perspective" road disappearing into
the distance or winding across the
canvas allowed him to give free
expression to his love of space.'

became a central theme, and it appeared in countless paintings. His
palette was considered scandalous – rich with buttery yellows, deep
lavenders and roses and bright greens. He painted in England, at
Hampton Court, on the Thames and at Charing Cross Bridge – scenes
which had been undertaken by Turner, Monet and even Pissarro over
the years. He painted at Argenteuil with Monet, revelling in the genius
of the other artist's astonishing eye. He wrote to his friend, critic
Adolphe Tavernier:

> *The subject, the motif, must always be simply rendered in a way*
> *that is comprehensible to the viewer and captures his attention. By*
> *the elimination of superfluous detail, the viewer should be led to*
> *share what it was that moved the painter to paint his picture in the*

first place. There is always, in a painting, something that the painter really loves. This is one of the reasons why Corot and Jongkind are so fascinating. After the subject itself, one of the most interesting qualities of a painting is movement, life itself.

Sisley remained loyal to this artistic vision, and while he longed for peace of mind so that he could concentrate on his work, he seemed to accept for the time being that fame was simply late in coming. But the fortunes of the group as a whole were diminishing. Many had become disheartened enough to release themselves from the associations of Impressionism. But for the most part, the painters had great faith in their art. It was this belief that led them to continue to exhibit, to brave the hostile storm, to find their feet amidst the maelstrom and thereby represent one of the most unique perceptions of art ever undertaken.

CHAPTER 3

High Impressionism

Conciseness in art is a
necessity and an elegance.
The verbose painter bores.
Who will get rid of all
these trimmings?

Manet

Overleaf:
Young Girls in the Garden at Montmartre, Renoir, 1893-5 (Christie's, London). This was painted at the beginning of Renoir's 'dry period', and while he has adopted a slightly more classical composition, the technique is pure Impressionist, alive with daubs of broken colour that provide a visual feast for the viewer.

Opposite:
The Umbrellas, Renoir, 1881-5 (National Gallery, London). One of Renoir's most important works, this painting reflects the change in style that occurred throughout his dry period. The right-hand side of the painting is evidently Impressionist in technique, the left shows the new classical influence.

By the third Impressionist exhibition in 1877 a body of grudging admirers had emerged. The Impressionists were out in full force: Monet showed thirty paintings, Degas twenty-five, Morisot twelve, Renoir twenty-one, Sisley seventeen, Cézanne sixteen and Pissarro twenty-two. But the new interest in the group was not reflected in sales, and despite some encouraging reviews, prices were low and for the most part, the group struggled.

Renoir had become unhappy with the labels he and his colleagues were receiving, and in 1878 he detached himself from the group, trying his luck again at the Salon. He said to Duret:

It is true that our exhibitions have served to make us known and in this have been very useful to me, but I believe we must not isolate ourselves for too long. We are still far from the moment when we are able to do without the prestige attached to the official exhibitions. I am, therefore, determined to submit to the Salon.

That year, The *Cup of Coffee* was accepted, and the following year *Portrait of Madame Charpentier and her Children*, and *Portrait of Mlle Jeanne Samary* were also chosen. His work was accepted and indeed celebrated within the art establishment, but outside that the public *en masse* had still failed to come to grips with the Impressionist vision.

The portrait of Madame Charpentier and her two children illustrated the new maturity of Renoir's work. He indulged his love of sensuous, rich colours and in an informal and light-hearted composition he created an extraordinarily flattering likeness of his new friend's wife and children. Renoir was desperate to make a good impression upon the society in which portrait painters could make a healthy living. There was no doubt that Renoir's paintings were remarkable. On the strength of *Madame Charpentier* and several other significant works, commissions for his portraits abounded. It's been said that more people were converted to Impressionism by Renoir's portraits than by any other single means.

Renoir's absence from the fourth exhibition, did, however, make his colleagues nervous. Pissarro had said to Caillebotte, who was organizing the show, '... if the best artists slip away, what will become of our artistic union?'

The only Impressionist to exhibit at all eight Impressionist shows, Pissarro had rejected the critic Duret's earlier advice:

You now have a group of art lovers and collectors who are devoted to you and support you ... but you must make one more stride towards being widely known. You won't achieve that by exhibitions put on by special groups. The public doesn't go to them. I urge you to exhibit at the Salon ...

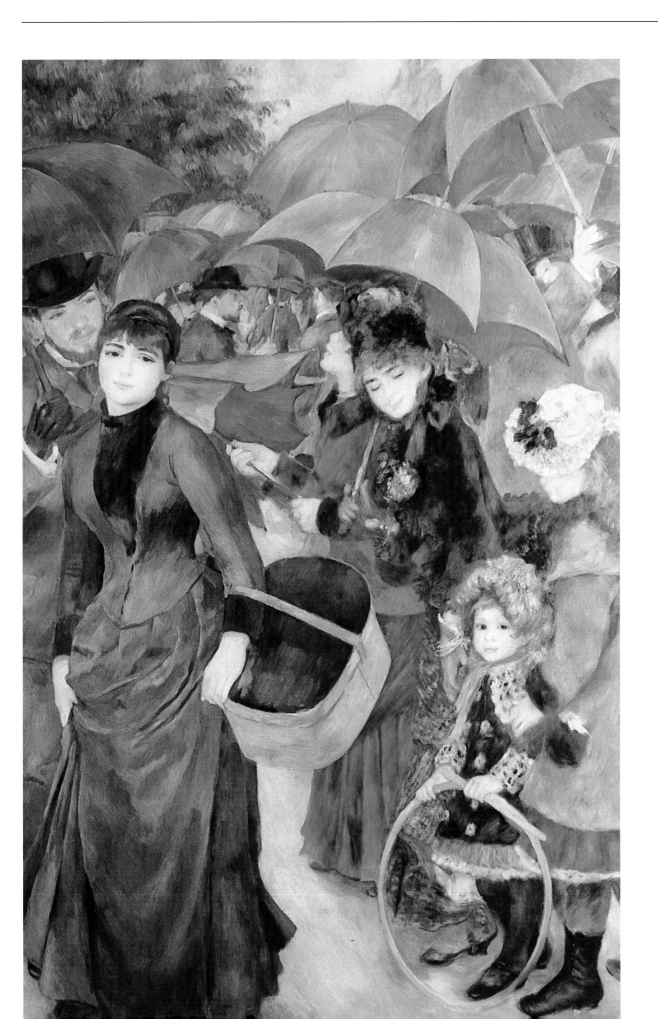

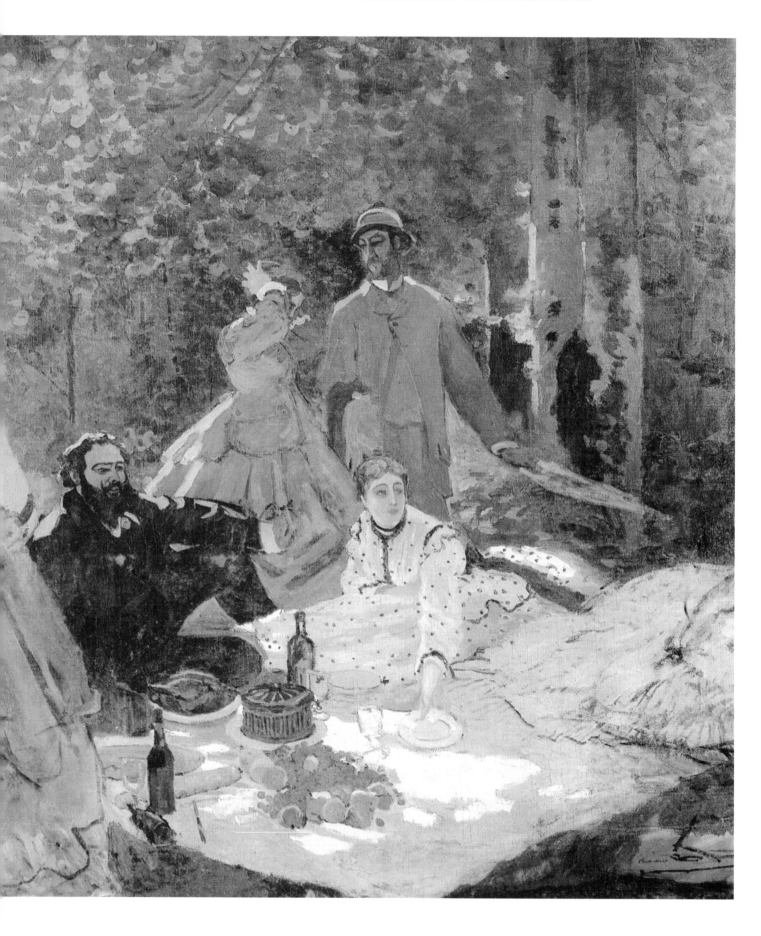

A devoutly political man, Pissarro had chosen a course for his art and intended to follow it. But he had a large family to support, and a wife who found it increasingly difficult to understand his particular brand of integrity. Pissarro and his wife returned to his family, in Britain, where they settled in South London, near Dulwich. Some of his most alluring landscapes were painted here, before their return to France.

The French economy was in the throes of depression and that, coupled with the fact that the Impressionists were not widely appreciated, did little to sell his paintings. Pissarro was committed to painting life as it really existed, refusing to idealize. He painted peasants, factories, working trains and poverty. His landscapes did not subscribe to the picturesque, and he avoided anything even vaguely sentimental. In the late 1870s, he turned to a more pronounced emphasis on figure painting, but when it was suggested, again by Duret, that his figures had a similar quality to them, he pointed out that he could not afford models, 'to make a proper study of the subject'.

Pissarro had become firm friends with Paul Cézanne. They worked together to develop a new, intellectual approach to their landscapes. Like Monet and Renoir in the previous decade, the two painters sat next to one another, painting the same motifs over and over again. An on-looker remarked that 'Cézanne plastered and Pissarro dabbed', making clear the distinction between Pissarro, who fulfilled his Impressionist promise, and Cézanne, who worked in his characteristic broad, heavy brushstrokes.

Paul Cézanne was born in 1839 in Aix-en-Provence, the son of a successful businessman. His great love of art was discouraged by his family and he made several abortive attempts to study in Paris, only to return home to Aix, overwhelmed by the career he had chosen. He met with Renoir, Pissarro, Sisley and Monet in the early sixties, and was exhibited at the first Impressionist exhibition, showing *The House of the Hanged Man, Auvers*, which was met with enormous hostility. The reception of his work did not improve, and by the third exhibition he had lost interest and faith in the aims of the group, resigning in 1887.

Cézanne was a discontented man, and after going through his self-described Impressionist period like many others, his aims remained different, and he disparaged many of his contemporaries, noting, 'I despise all living painters except Monet and Renoir.' He enjoyed the company of Pissarro, however, and the two painters sparked off one another, developing the Impressionist philosophy into something much more profound. Both intellectuals, they felt that landscape art could only be successful if it was invested with the creative imagination of the artist. The artist must, therefore, react to a motif within nature and paint from the inspiration it produced. Martin Reid, in *Pissarro*, writes:

Déjeuner sur l'Herbe, Monet, 1865-6 (Musée d'Orsay, Paris). This is the central panel of Monet's famous painting, fashioned after Manet's work, but actually painted out of doors. In order to pay his rent, Monet rolled up this work and left it with Bazille. It was discovered many years later, mouldered and much of it destroyed.

The problem was how to portray volume and depth, light and shade, and to do so in a way which made an interesting multi-textured picture. In practice this meant laying on the paint very thickly and enriching the colours. This was pioneering work, and it was expensive since it required a lot of time and costly materials – and the resulting pictures were not as saleable as traditional ones. There were fewer of them, too. But many scholars regard these paintings as Pissarro's very best. Familiar landmarks along this road are La Côte des Boeufs, Le Pêcheur à la Ligne *and* The Backwoods the Hermitage.

By 1880, the tide had turned for the Impressionists. The economy had begun to pick up, and Durand-Ruel was buying paintings again. In 1880 Monet also struck up his association with Durand-Ruel again. Monet had become good friends with Pissarro in London, where both artists had fled following the outbreak of the Franco-Prussian War, and they kept in close contact through the years. But Monet disagreed with Pissarro's vision for the Impressionist school. Pissarro had insisted that the works of his pupils, Gauguin and Vignon, be included in the 1882 exhibition, and Monet had vehemently objected. Monet had also alienated himself from his peers by organizing his own show at *La Vie Moderne* in June 1880. On Renoir's advice he had also submitted work

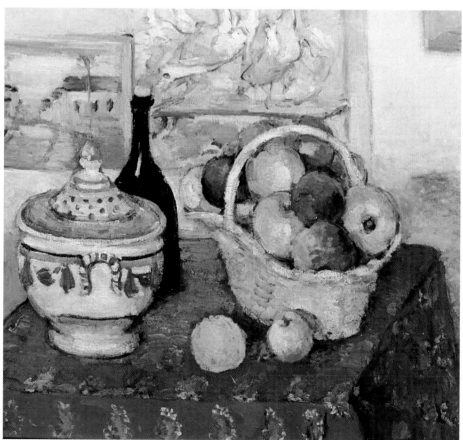

Still-life with a Tureen, Cézanne, 1877 (Musée d'Orsay, Paris). Although Cézanne only flirted with the Impressionist movement, his work is largely responsible for taking it into the twentieth century. His work became representative of the post-Impressionist movement, which expanded to become Expressionism.

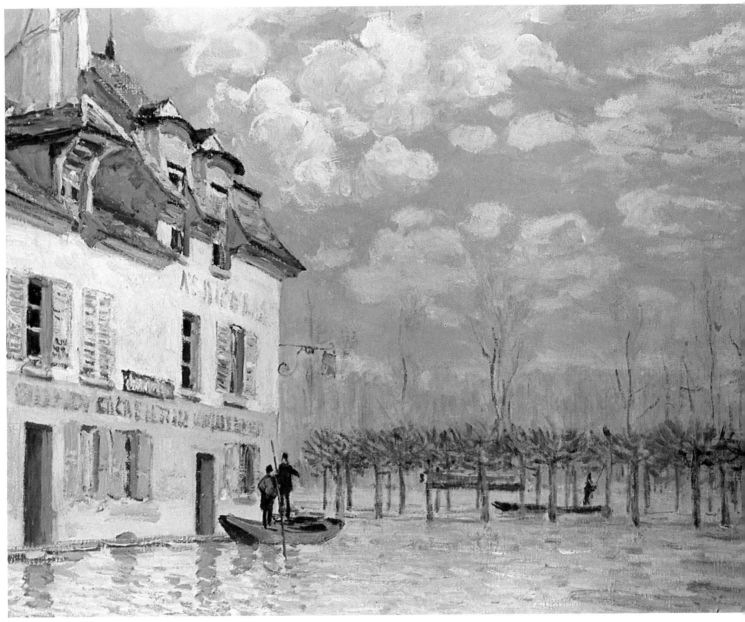

to the Salon: *The Ice-Floes on the River at Bougival* and *Lavacourt*, only the latter of which was accepted. *The Ice-Floes* became the centre of his one-man show, and it was purchased for a relatively large sum of money.

Edgar Degas called Monet a traitor for denying everything the Impressionists stood for by showing at the Salon, but Monet was perhaps rightly distancing himself from the Impressionist group, who had begun to expand beyond their original precepts into something quite different.

The exhibitions were never restricted to members and not all members exhibited in every one, but problems as to who should be allowed to show with the group were beginning to arise. Degas, whose work was more realistic than many of his counterparts and who consistently shirked the Impressionist label, was keen to encourage

Boat in the Flood at Port-Marly, Sisley, 1876 (Jeu de Paume, Paris). Sisley's Port-Marly work comprised much of his one-man show at the *La Vie Moderne*, which he was convinced by Monet to do. The show was a complete failure. The work that appeared there is some of the most luminous and brilliantly coloured of the entire Impressionist movement, but it was universally derided.

new artists. Most of the others in the group saw this as a compromise of their aims and in 1880 Monet's excuse for failing to join the group show was that 'the little clique has become a great club'. He explained his decision, saying, 'I believe that it is in my interest to adopt this position because I can have more confidence in business, in particular with Petit, once I have forced the door of the Salon.'

Monet had a young and very large family to consider; Salon success was the key to financial stability and he had spent too long seeking this to throw it all away on a movement that appeared to be on its last legs. While he still agreed with its principles, all was well, but there seemed to be a new breed of adherents, some of whom expressed the views of the group in a way that Monet considered wildly unsuitable.

Sisley had also left the group, doubting the possibility of any future unity and concerned about the use of the Intransigents label. He had, despite growing poverty, clung to his vision for the group of painters, and had remained loyal to their aims. He waited patiently for success which did not, sadly, come until shortly after his death. Georges Charpentier came to his rescue several times, as did the pastry-maker Eugene Murer, who was never adverse to accepting a painting when the patrons of his restaurant ran up too high a tab. Sisley and his family were regular diners at Murer's restaurant in Paris, and they were joined there by a number of other poverty-stricken Impressionists, like Renoir, Pissarro, Cézanne and Guillaumin. Murer's collection of Impressionist paintings, given in lieu of payment, was one of the finest in the country.

In a desperate bid to draw attention to his work, Sisley decided to present his work to the Salon again in 1879. He wrote to his friend Duret:

> I've been sitting here vegetating for far too long now – I am tired of it. The time has come to make a decision. It's true that our exhibitions have been helpful in getting us known, and for that they have been useful, but I don't think anyone should stay in isolation for too long ... I've decided to send some of my work to the Salon. If I am accepted, and that may be possible this year, I think I might be able to sell something ...

Sisley's work was not accepted, however, and he was evicted from his home. He entered the 1880s with a resigned attitude, wanting more than anything to have the luxury of exhibiting solely with the Impressionists but understanding only too well the reality of his situation. He moved constantly around the country, calling upon the generosity of patrons and friends in order to keep his family together.

Monet convinced Sisley that a one-man show, rather like his own, was the contemporary key to success for those whom the Salon had shunned. In the spring of 1883 Sisley agreed, and provided seventy

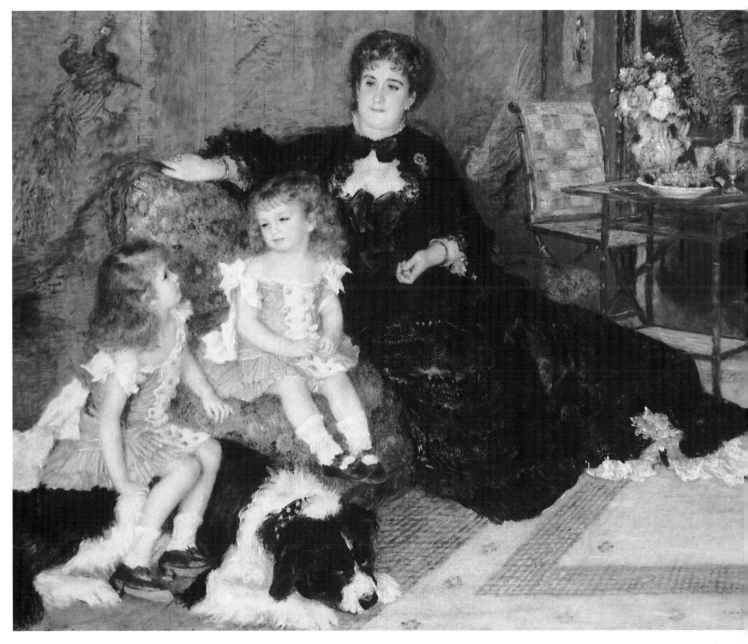

beautiful paintings, some of the most serene and luminous of all of the Impressionists. It failed completely. Paintings like *In a Boat at Veneux* and some of his best works from Port-Marly and Moret were dismissed out of hand. He struggled to apply new techniques to his art, in order to win a new audience, but the fluidity of his earlier work gave way to a more robust line which made his works appear lifeless, much more empty. In the *Préface d'Exposition Alfred Sisley*, Claude Roger-Maux, says:

> *Even in the series painted at Moret, Saint-Mammes and Veneux-Nadon, we still often find the angelic tones of his earlier work. Insisting always on what he affectionately called 'the part of the*

Portrait of Madame Charpentier and her Children, Renoir, 1878 (Metropolitan Museum of Art, New York). This painting assured Renoir's success at the 1879 Salon, making him a celebrity in the literary and political circle of the Charpentiers. The grouping is keenly rendered, and the flesh tones of the children in particular unparalleled in contemporary art.

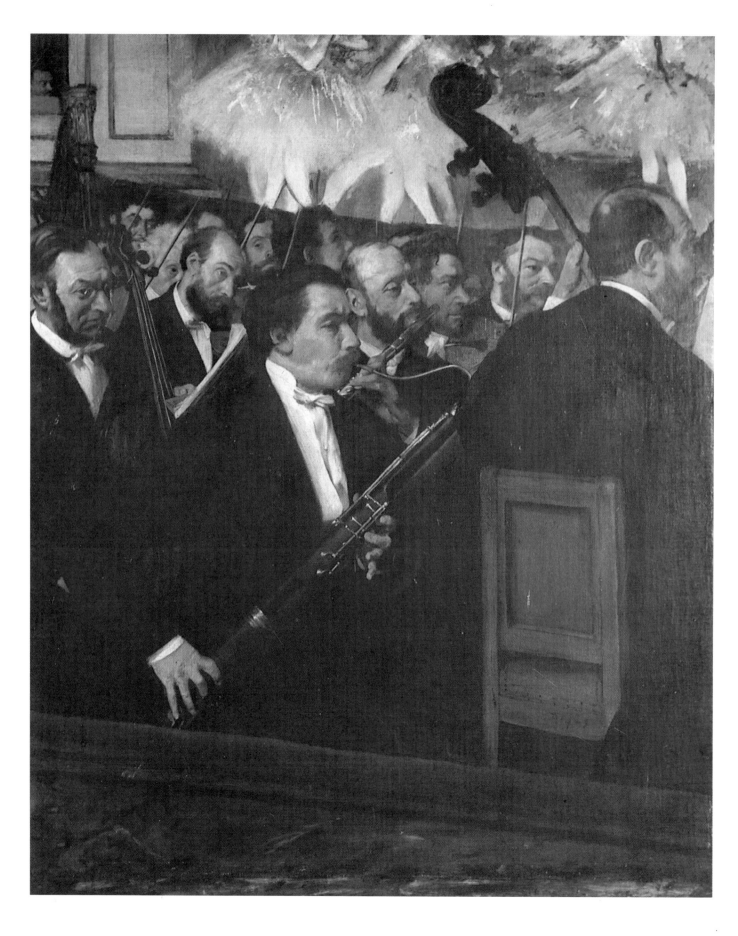

painting the artist loves', Sisley makes the light shimmer in the leaves of poplars along a river or canal with the same gentleness of effect. Even when his hand seems to falter, his heart is not for that reason any less sincere ...

Sisley was forced to create even when he was not inspired. He moved around France searching for themes which would imbue him with that same old reckless enthusiasm. He painted again in England, returning to favourite haunts and finding inspiration once again on the Thames in London. His particular crisis, if it can be called that, was based around his constant need for new stimuli and the urgent and abundant nature of his output. He exhausted subjects completely, finishing up to three hundred on the same subject. He wrote once: 'The new is not found in the subject itself but in the way it is rendered' and he explored every possibility offered by a scene or motif.

Renoir had moved away from the group through his own artistic crisis. Other Impressionists had drifted away, some alarmed by the changing focus of aims. Many swallowed their integrity and began to submit work to the Salon once more, accepting the fact that pride in one's work and a strong show of righteous rebellion did not pay for canvas or paint, or indeed put shoes on feet and bread in mouths. But a new faction was emerging from the old school of Impressionism, and with it came a fresh source of light.

The Paris Opera, Degas, 1869
(Musée d'Orsay, Paris). This painting is one of Degas' greatest works, an experimental picture which ruthlessly cuts the heads from the dancers, and takes the sides from the orchestra itself.

Haymakers, Evening, Pissarro, 1893
(Joslyn Museum of Art, Omaha) Painted several years after his famous *The Gleaners*, this work is representative of Pissarro's experiments with pointillism under the influence of Seurat. The technique was a development of the Impressionist approach to colour and brushstrokes. This work was often considered to be stiff and unrealistic, because of the limitations of the style.

CHAPTER 4

The Later Years

Anyone who says he has
finished a canvas is
terribly arrogant.

Monet

Overleaf:
The Garden Path, Giverny, Monet, 1902 (Private Collection). Monet's garden at Giverny was famous across the country. The expanse of colour and light was ever-changing, daily and seasonally, when different plants were encouraged to flower, and Monet painted them with an ever-deepening palette.

Manet had finally received acclaim when, in 1879, two paintings – *Boating* and *In the Conservatory* – which he submitted to the Salon were accepted, and were well received. That same year, a new journal entitled *La Vie Moderne* was published, designed to bring 'spiritual distractions and civilized joys' to the Parisian reader. Art and literature were among the subjects it discussed, and from the summer of its conception, it sponsored a series of exhibitions devoted to a single painter. Renoir was the first painter to be exhibited, and Manet was next. He was gratified to see his *enfant terrible* label had slipped, and he was now fêted as an artist of distinction.

Throughout his career, Manet had firmly believed that he would eventually achieve recognition, but he was wounded by the time it had taken, saying, that fame was all very well, but it had come years too late. Phoebe Pool, in *Impressionism*, comments on Manet's enormous influence on the Impressionists:

> It is hard to think of any other great nineteenth century painter whose originality and whose legacy to succeeding generations have been so foolishly belittled, not only in his lifetime ... but right down to the present day... His reputation in France may have suffered from the hostility of Degas's supporters ... but if [they] undervalued Manet, it was clear that Degas himself and the Impressionists did not.

Manet never exhibited with the Impressionists, and was often disdainful of them, but their influence on him is undoubted. He was as important to the conception of the Impressionists as they were to his later success. Time spent painting with Morisot and Monet brought a new lightness to his canvases, and a purer use of colour that surpassed even his own revolutionary techniques. Later works like *Spring* and *Bar at the Folies-Bergère* (1882) confirm his ability to portray the world around him with astonishing accuracy. The strength of his vision never wavered, and it is undeniably sad that by the time critical approval was his, he was in fact ill, and dying. He died in 1883, following the amputation of his left leg. He left a legacy of instinctive and supremely modern art.

Monet was a pallbearer at Manet's funeral, and he grieved for the older painter. His own work had developed a more focused, deep-seated approach to Impressionism. He built himself a world in his garden, which he painted increasingly in his older years. His garden at Giverny became famous, a veritable mecca for art lovers across the decades. He travelled extensively, even in his later years, delighting in the effects of colour and light and atmosphere, and struggling to render them with a more vibrant palette.

He became obsessed with capturing every single effect of light and was often surrounded by a dozen canvases which he quickly

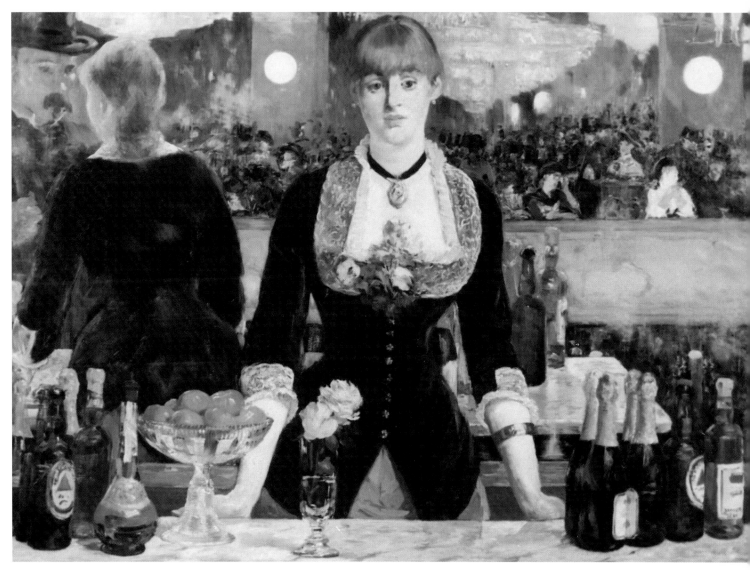

rotated as time passed. He gloried in the sunlight; the rain would drive him to angry tears and he would refuse to leave the house. The sunlight created everything his art represented; blackened skies filled him with depression and frustration. He had studios built on his land at Giverny, larger, better lit studios to house the growing size of his paintings, and the ever increasing number of paintings in each series.

Rouen Cathedral and the *Thames* in London were early examples of Monet's series paintings. He had become convinced that one painting was unable to do justice to a scene, that a motif must be examined in a series of paintings, which would portray the subtle changes that were, in the end, the makings of a new subject altogether. On his travels from Giverny he was often required to hire a porter to carry his canvases, and a trip abroad would be considered wasted if the weather changed dramatically and he was unable to continue with the work he'd begun. The fogs of London had fascinated him, their everchanging colours swirling and then abruptly changing with the weather.

Bar at the Folies-Bergère, Manet, 1881-2
(Courtauld Institute, London).
Manet exhibited this painting at the 1882 Salon, the last one he ever attended. The theme of this painting was a return to the Baudelairian idea of 'the heroism of modern life', which was one of the fundamental ideologies of the Impressionist movement.

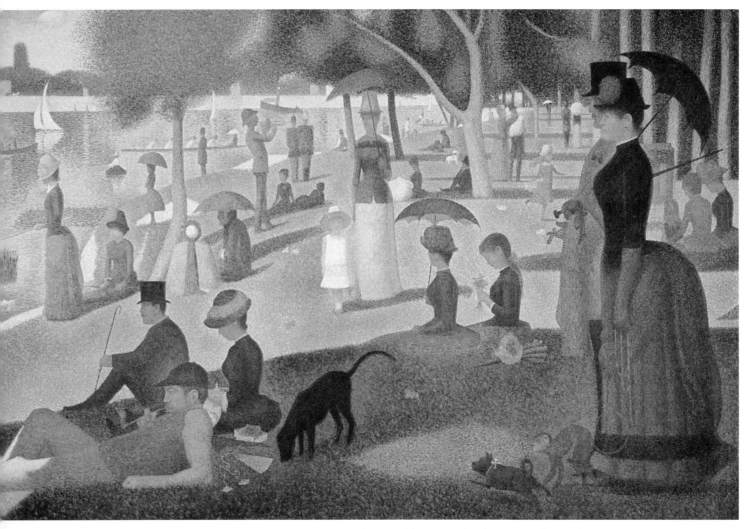

La Grande Jatte, Sunday, Seurat, 1884-6 (Chicago Art Institute). One of Seurat's greatest works, this represents his pointillist technique, which was the natural progression of Impressionism. He painted with Pissarro, and both men experimented with the style which would become known as neo-Impressionism.

He was exhilarated by London's unpredictable weather – a rare burst of sunshine followed by heavy storms that passed only minutes later, leaving a flush of radiance in the air, fabulous sunsets, sinking in the shrouded mists – but he would be driven to fits of apoplectic anger by the insistent rain which would make it impossible for him to work for days on end.

Rouen Cathedral was another fascination, and it enthralled Monet to the extent that he painted no fewer than thirty representations of its façades, works in which the whole of the front of the splendid building filled his canvas, becoming both the subject and the composition. He painted it as the light changed: he observed the passing effects of light, throughout the day. For two years, from February to April in each, he recorded the cathedral in various lights and weathers. The *Rouen* series was greeted with enormous critical acclaim; Monet was now considered one of France's greatest painters and buyers came from around the world at the whisper of a Monet sale.

Monet's *Grainstacks* (*Haystacks*) were another tremendous achievement. Here he moved closer to home, working on a single, unassuming

everyday sight, which he realized could be rendered as beautiful and different by the changing light as any foreign or exotic subject. *Poplars* was another series, in which the same visual motif was repeated again and again and studied under the varying conditions of a day. From London he wrote in 1900:

> *I've never seen such changeable conditions and I had over 15 canvases under way, going from one to the other and back again, and it was never quite right; a few unfortunate brushstrokes and in the end I lost my nerve and in a temper I packed everything away in crates with no further desire to look out of the window, knowing full well that in this mood I'd only mess things up and all the paintings I'd done were awful, and perhaps they are, more than I suppose.*

From his base in Giverny Monet retained an extremely important position among the artists and writers in Paris, losing many of his Impressionist ties but forging for himself a new status within the intelligentsia. He continued to meet many of his former colleagues at the

Haystacks, Monet, 1893 (Private Collection). One of the *Grainstack* series of paintings, this work was painted in a farmer's field near Giverny; the locals, suspicious of this eccentric painter took great pleasure in dismantling haystacks as he painted.

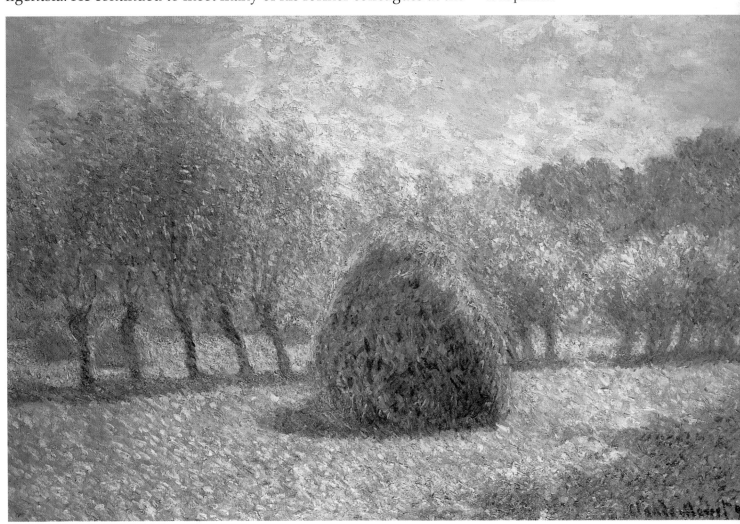

Place du Théâtre Français, Paris, Pissarro, 1898 (Los Angeles Country Museum of Art). Pissarro became the master of the urban landscape, and this is one of his finest explorations of the genre. The painting is reminiscent of Monet's *Boulevard des Capucines*, and employs Pissarro's particular brand of Impressionism, which he adapted to suit his needs.

home of Berthe Morisot, and he attended a monthly dinner at the Café Riche in Paris, to see still others. Of his older friends, Cézanne continued to visit Monet, which both considered an honour – Cézanne because he liked only Renoir and Monet of all contemporary painters, and Monet because Cézanne's work echoed much of what he believed to be essential to good landscape painting: that nature must be studied at first hand. The two painters' regard for one another was evident throughout their works. Until his death, Sisley was also a good friend, writing often to Monet and visiting, with the others, the wonderful gardens of Giverny. Their ties weakened when Sisley withdrew from his circle of artist friends, but Monet was instrumental in organizing an auction of paintings following Sisley's death in order to help his children.

Monet died in December 1926, at the age of eighty-six, the supreme master of Impressionism. His *Water Lilies* have become icons of the Impressionist movement, pure Impressionism allowed to run its natural course.

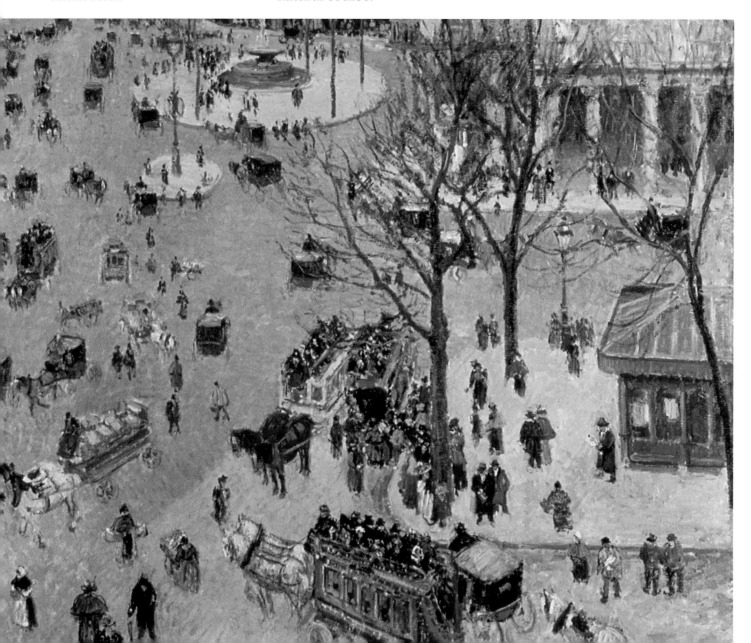

Waterloo Bridge, London, Monet, 1903
(Private Collection). One of the *Thames* series paintings, Monet painted this same scene over and over again, as the light and atmosphere changed. London's weather both inspired and infuriated him.

Renoir had moved away from Impressionism some years earlier, during an artistic crisis which led to his 'dry period', or *periode aigre*. He said:

About 1883 I had wrung Impressionism dry, and I finally came to the conclusion that I knew neither how to paint nor how to draw. In a word, Impressionism was a blind alley, as far as I was concerned ...

He had ceased to paint exclusively from nature. Instead he developed a system which depended on a large series of sketches and preparatory studies for each work, one which harked back to traditional schools of art and indeed his early days at Ecole des Beaux-Arts. He expressed his new disenchantment with painting out of doors, where his preoccupation with form made it impossible to work at any speed. He said:

There is more density of light in the open air than in the studio where it remains unchangeable, whatever your intention or purpose may be. But this is precisely the reason why light is too important in the open air. There is no time to work out a compromise, and you can't see what you are doing.

Bridge at Giverny, Monet, 1893
(Private Collection). Monet created a spectacular water garden at Giverny, complete with a Japanese bridge. Along with the water lilies, it would become a central motif in his work. This painting is illustrative of his brighter palette, following his trips to Bordighera.

While Renoir's later work took on a stronger compositional element, with greater emphasis on contour and delineation, he nonetheless continued to paint with the light palette and breathless brushstrokes that characterized most of his work. By the end of the eighties Renoir was beginning to savour the success of a mature and acclaimed artist. He was content with his art, with his family, but he was struck down by illness at this time. Within a decade he was wheelchair-bound, the result of debilitating arthritis. Perhaps due to his training as a porcelain painter, however, and to the rigorous retraining he gave himself in the eighties, during his dry period, Renoir's work retained

its fluency and delicacy. He was able to maintain remarkable agility despite the fact that he was often unable to hold a paintbrush.

But Renoir derived a new and even greater pleasure in painting the simple things in life, and while his illness prevented him from travelling, it did allow him to savour the warmth of his family, and the everyday events that would become the new subjects for his work. Renoir had finally found some satisfaction with his art and no longer sought the reassurance and inspiration of his contemporaries.

His illness prevented him from producing large-scale works, but smaller paintings were rigorously turned out, and sketches from that period abound. In the early years of the twentieth century, Renoir adopted a palette that was more spartan; later, red became a predominant colour and he used paint in a much more lavish manner, retaining at once the fluency of his earlier technique and endowing it with a sort of reckless enthusiasm.

His nudes became bigger, more robust, somehow warmer. He painted women at work in the fields, washing clothing, preparing for the bath. His strokes were broader, due to his illness, but his paintings retained their precision and eloquence. Some of his most famous paintings of this time include *Washerwomen*, a rich celebration of a country woman's lot. He maintained the same ability to depict human interaction throughout his career; in the early years it manifested itself in his buoyant portrayals of Parisian café society, later he illustrated the relationship between his child and her nurse, or two maids in the garden. His latest works were in many ways his most honest, his most luminous. His garden at Les Collettes became a haven, a place in which he could create a world unlike the one outside which had let him down.

Renoir continued to work until his death in 1919. When he could no longer hold a paintbrush, one was strapped to his hand, the skin protected by a handkerchief. His last great masterpiece, *The Bathers* (1918) is as rich and moving as any of his earlier work, his genius taking root in his mature years to become a tree of self-confidence, sensuality and above all unsurpassed joy.

Pissarro had lost touch with Renoir many years before his death, Renoir having despaired of Pissarro's politics, feeling they had no place in artistic circles. Although Pissarro had remained true to his Impressionist background, the group itself was falling apart. Caillebotte blamed Degas, and in a letter to Pissarro wrote:

Degas introduced disunity into our midst ... He claims that he wanted to have Raffaelli and the others because Monet and Renoir had reneged and that there had to be someone ... He claims that we must stick together and be able to count on each other ... and whom does he bring us? Lepic, Legos, Maureau ... All this depresses me deeply.

Woman Combing Her Hair, Renoir, 1907-8 (Musée, d'Orsay, Paris). As Renoir grew older, his illness made it very difficult for him to hold a paintbrush, and his strokes grew broader and less defined as a result. This is an example of his later work, in which his women have a richer, more mature aspect.

Bathers, Renoir, c. 1918–19 (Musée d'Orsay, Paris). Renoir's last finished masterpiece, this painting boasts confident brushstrokes, making it not a satire, or an exercise in voyeurism, but a strong and sensual celebration of the female form, which he had painted unceasingly throughout his career.

At the same time Renoir had written to Durand-Ruel that 'To exhibit with Pissarro, Gauguin and Guillaumin would be as if I were exhibiting with some Socialist group.' Degas had also alienated Renoir and many others by insisting that anyone showing at the Impressionist exhibitions could not show at the Salon as well. The Impressionists broke into two factions, one headed by Degas, and including people like Cassatt, Raffaelli and Forain, and the other headed by Caillebotte, and consisting of Pissarro, Monet, Renoir, Morisot, Guillaumin, Sisley and Gauguin. Renoir did not feel at home with either, however, and moved even further from their circles.

He and Monet both avoided the eighth Impressionist exhibition, as did Sisley and Caillebotte, but two outsiders had appeared and were demanding attention. The traditional Impressionists argued their inclusion, but they were the new envoys of Impressionism and helped take it into the twentieth century. The two men were Georges Seurat (1869–91) and Paul Signac (1863–1935), and they developed the technique of pointillism, or divisionism, where Monet's use of pure colour was broken down even further, painted not in short, sharp brushstrokes, but in tiny dots of evenly laid pure colour. The art of these two

men was undertaken in the studio, but their subject matter remained much the same as their precursors, and they came to define neo-Impressionism, or what Pissarro considered the natural extension of the Impressionist movement.

Cézanne had once said that if Pissarro had continued to paint as he had in the 1870s, he would have been 'the strongest of us all'. His biographer, Martin Reid, examines the reasons why Pissarro never really achieved the success for which he so longed:

> ... the constant self-doubt ... led him in the 1880s to adopt a technique that was not at all suited to him ... the penury brought him near to despair. Another probably lies in the political idealism, which gives many of his best paintings their peculiar moral strength, but could on occasion become over-insistent and monotonous ... he was inclined to be over-impressed by theories that smacked of science, such as pointillism. It was the work of gifted young men, and it had respectable ... credentials. Pissarro threw himself into it for a while, but it was ultimately unsatisfactory and it cost him dearly.

When he died in 1903, he was surrounded by his family. One way or another he had managed to support his wife and seven children, never really compromising his beliefs. Most of his sons turned to art as a career, and he said to them, 'One must want to find, and end up knowing, what one wants.' His later work, much like that of Monet, consisted of series paintings which often included over forty impressions of the same motif. He produced some remarkable depictions of urban landscape, which have earned him his justified place in the history of the genre.

Sisley, too, had died in virtual poverty, but he had found continual enjoyment in his work, never regretting his decision to give up what might have been a successful commercial career. He held the same fascination with light as Monet and Renoir, and he used unconventional colours in his portrayal of light and air. He had an extraordinary ability to paint water – the Thames in London and the Seine in France, glorying in nature and all it offered. His deep love of the countryside led him across the continent and throughout England, searching for new inspiration and atmospheric effect. Sisley's reputation was established only a year after his death, when his paintings began to attract high prices and critical acclaim. It came too late for him, but he knew, instinctively, that it would happen and it was that belief which helped to ease the pain of the journey.

Caillebotte had died in 1894. His painstaking work on behalf of the movement was probably one of the most important reasons for its eventual success. His money meant that he was not only able to

Water Lilies, (Nymphéas), Monet, 1907 (Houston Museum of Fine Art). The *Water Lilies* paintings required years of painting, overpainting, scraping and retouching before Monet was satisfied with them. Even then, many were discarded and later burnt.

support many artists, acting as patron, but he was also able to use his influence in order that his friends would do the same. He personally purchased a large number of the Impressionist paintings, on a par with Paul Durand-Ruel, the other Impressionist champion, and upon his death left the entire collection to the State. Embarrassed by the gift of art which it deemed unsuitable, the Louvre rejected a large proportion of the collection.

Impressionism had taken on a different meaning with the main members' contributions. Those who had merely flirted with the group – Seurat and Cézanne, for instance – infused it with a unique perspective, one which celebrated the richness of its vision and the very real changes it was making in the history of art. Many of the original members, including Cassatt and Degas, moved on to post-Impressionism and Symbolism, distinguished by the talents of Van Gogh, Pierre Bonnard and Gauguin. These movements would never have evolved, without the existence of Impressionism, and their main characteristics are derived from the very real influence of the movement which preceded them.

By the turn of the century, Impressionism was the approved school of painting. In 1904, in *Mercure de France*, Mauclair, a conservative and highly regarded critic wrote:

> *It is absolutely evident that Manet, Monet, Renoir and Degas have created masterpieces that can rank with those in the Louvre and the same might be said of some of their less famous colleagues ... it brings the nineteenth century to a glorious finish and presages well for the next. It has accomplished the great feat of having brought us once again into the tradition of our great national heritage.*

The original Impressionist movement ended with the show of 1886. While all of its proponents continued to paint, they never showed together again and their individuality was encouraged. The extent to which Impressionism affected the art that followed it is undeniable. The movement exemplified the modern spirit; the artists painted what they saw without pretence or emotion. They painted pleasure, and created works in which light is everywhere – even in the shadows. The Impressionists transformed our way of looking at art, and even at looking at nature. In that sudden brilliance, much of the painting that came before seems dull and uninspired. The flash of light that was Impressionism brought to life a culture and a time that required that kind of reproduction, and for that they are probably the most celebrated and popular group of artists who have ever lived.

Young Peasant Girl, Pissarro, 1881 (Musée d'Orsay, Paris). Pissarro avoided the idealization of country life that was popular in the early nineteenth century. Cézanne once said that if Pissarro had continued to paint as he had in the 1870s, he would have been 'the strongest of us all'.

INDEX

Bazille, Self-Portrait, 1865
(Chicago Institute of Art)

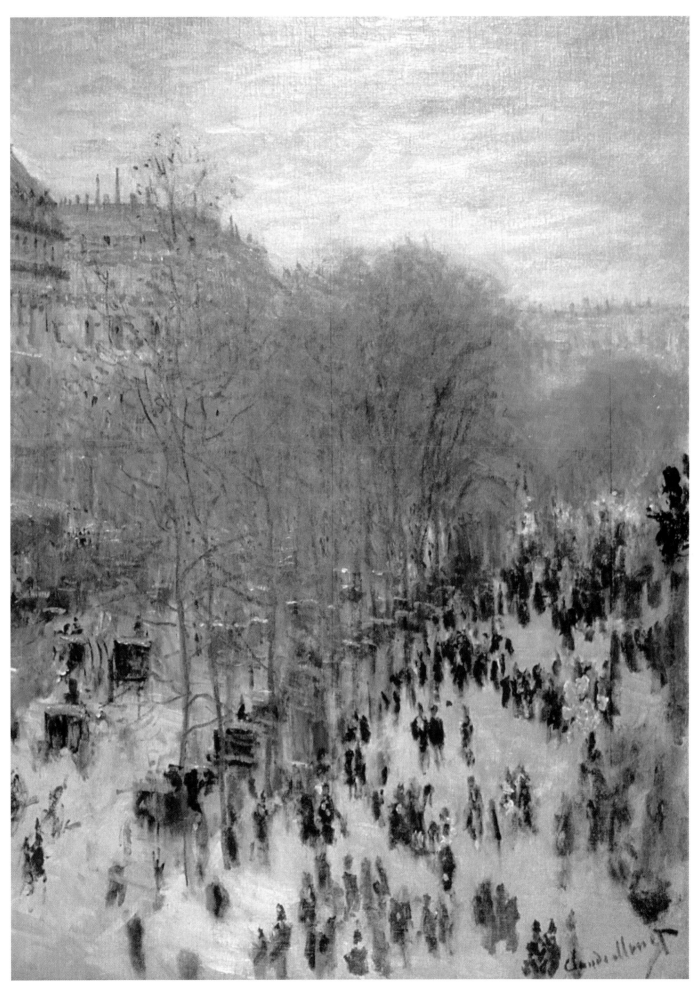

Monet, Boulevard des Capucines, 1873
(Nelson-Atkins Museum of Art, Kansas City)

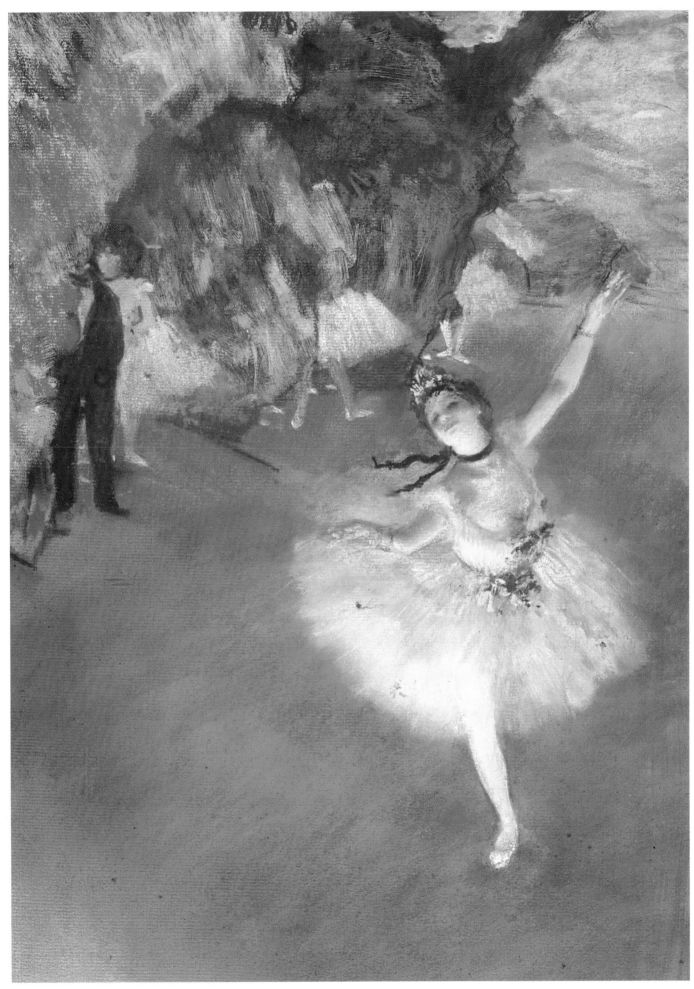

Degas, The Star, 1878
(Musée d'Orsay, Paris)

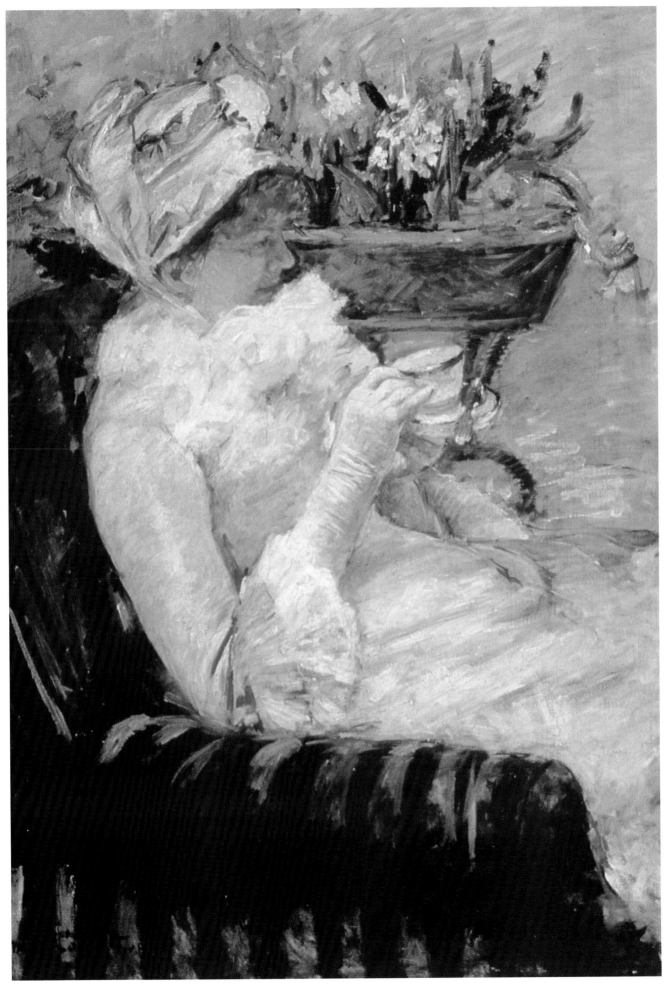

Cassatt, The Cup of Tea, 1879
(Metropolitan Museum of Art, New York)

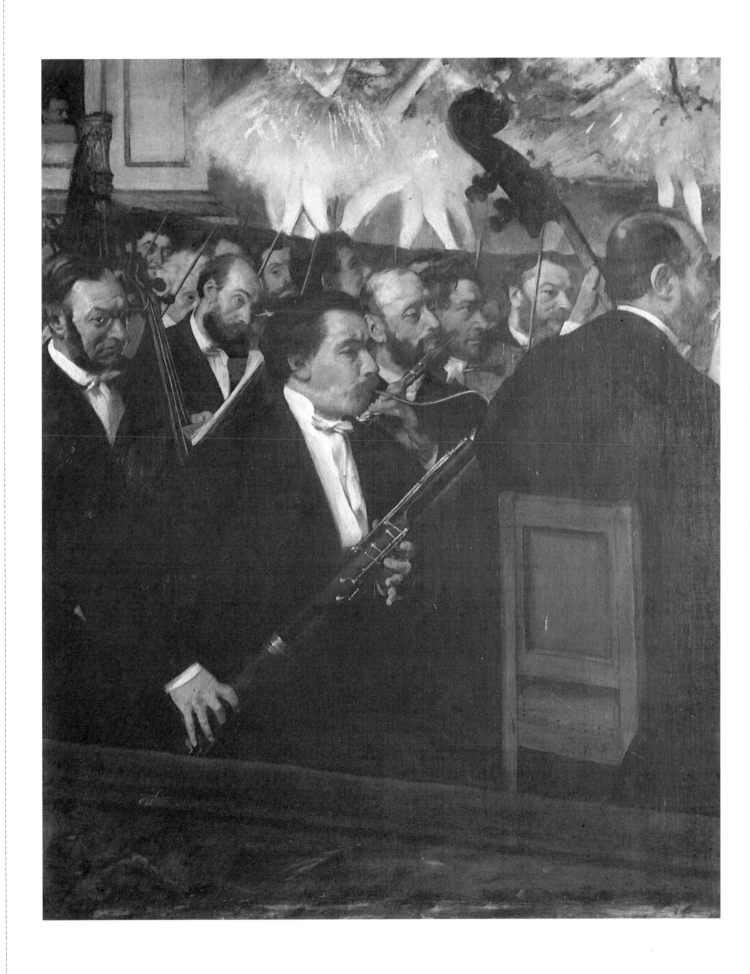

Degas, The Paris Opera, 1869
(Musée d'Orsay, Paris)

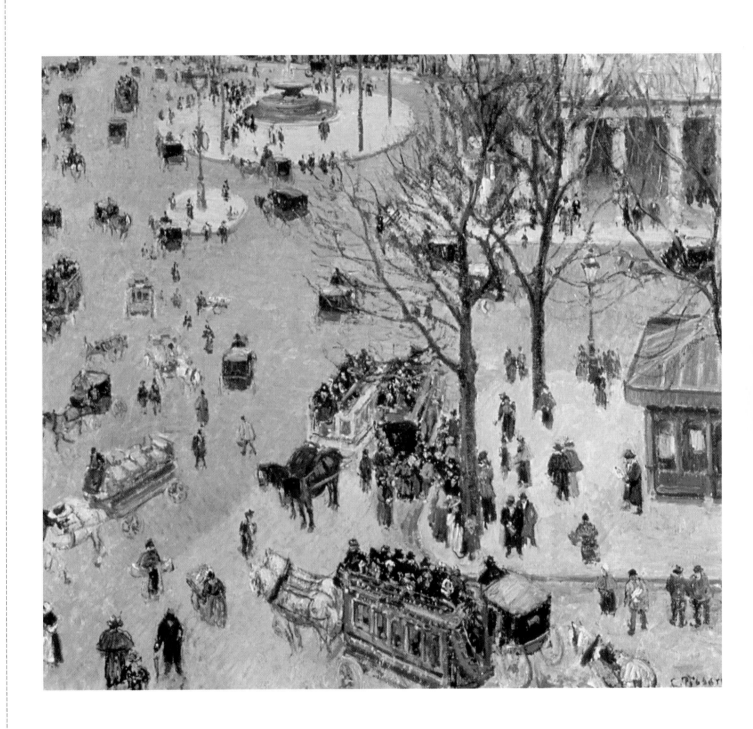

Pissarro, Place du Théâtre Français, Paris, 1898
(Los Angeles Country Museum of Art)

Renoir, Woman Combing Her Hair, 1907-8
(Musée, d'Orsay, Paris)

Pissarro, Young Peasant Girl, 1881
(Musée d'Orsay, Paris)